IMAGES
of America

FOREST HILL
THE ROCKEFELLER ESTATE

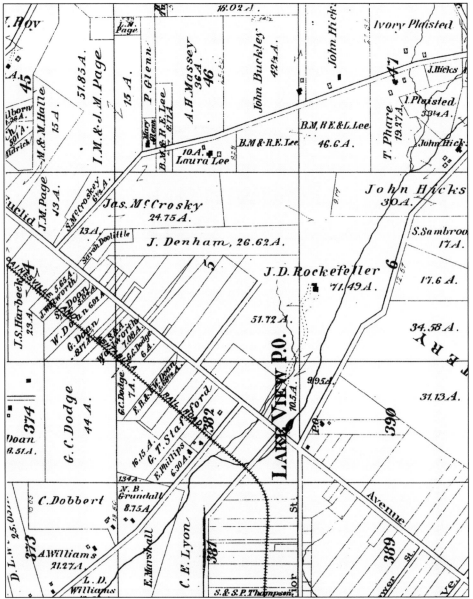

Published in 1881, the *City Atlas of Cleveland Ohio is* one of a series of atlases that help piece together the story of Forest Hill. This one is particularly invaluable as it identifies Grove Street, which led to the Euclid Avenue Forest Hill Association's hotel and water cure and later became the main entrance to the Forest Hill estate. It also shows the Dugway Brook, Rockefeller Brook, the route of the Lake View and Collamer Railroad, and the farms surrounding Forest Hill. (Courtesy of the Cuyahoga County Archives.)

On the cover: In the 19th century, Forest Hill, the Rockefeller estate and residence, dominated the top of a hill in East Cleveland Township. Situated on a ridge of land known as the Heights, the mansion looked out toward Lake Erie. Its broad lawns, long verandas, and open windows captured summer and the heart of one of the most famous families in America. (Courtesy of Cleveland State University Special Collections.)

IMAGES
of America

FOREST HILL
THE ROCKEFELLER ESTATE

Sharon E. Gregor

ARCADIA
PUBLISHING

Published by Arcadia Publishing
Charleston, South Carolina

Printed in the United States of America

Library of Congress Catalog Card Number: 2006926574

For all general information contact Arcadia Publishing at:
Telephone 843-853-2070
Fax 843-853-0044
E-mail sales@arcadiapublishing.com
For customer service and orders:
Toll-Free 1-888-313-2665

Visit us on the Internet at www.arcadiapublishing.com

CONTENTS

ACKNOWLEDGMENTS

I am grateful to the following individuals and organizations who provided photographs and information: William C. Barrow, Cleveland State University Library, Special Collections; Lois Cook; Tara C. Craig, Butler Library, Columbia University; Carl Engel, Morley Library, Painesville, Ohio; Forest Hill Church Presbyterian; Forest Hill Historic Preservation Society; Edward Frost; Michele Hiltzik, senior archivist, Rockefeller Archive Center; Terrance Hood; Christopher Hubert, Forest Hill Home Owners; Ryan Jaenke, Cleveland Public Library; Mary C. Krohmer, Lake View Cemetery Association; Dr. Walter Leedy; Eric Linderman, East Cleveland Public Library; Laura McShane, Cleveland Public Library; Steven Morchak; Sue W. Neff, executive director, A. M. McGregor Home; Kara Hamley O'Donnell, historic preservation planner, city of Cleveland Heights; J. Steven Renkert; Dr. Kenneth W. Rose, assistant director, Rockefeller Archive Center; Tony Rupsic; Anne Sindelar, reference supervisor, Western Reserve Historical Society; and William B. Weisel. Images without a credit are from the author's collection.

I wish to thank my editor, Melissa Basilone, for her advice, patience, and enthusiasm about the subject of this book. I also wish to acknowledge Arcadia Publishing, which has made America's history and heritage so appealing and accessible to so many people.

I am particularly grateful to Dr. Marian Morton, who encouraged me to write about Forest Hill and offered much-appreciated guidance. For their generous assistance in the research of this book I wish to thank the following: Dr. Judith G. Cetina, county archivist, Cuyahoga County Archives; Greg Reese, executive director, East Cleveland Public Library; and Mayor Eric Brewer, city of East Cleveland.

Finally, I dedicate this book to my son, John Baxter Gregor. Although he once jokingly asked me why I had filled his head with such things, he loves history and architecture, his hometown of Cleveland, and his adopted city of New York.

From 1985 to 1987, Sharon Gregor coordinated the effort that placed the 81 Rockefeller Homes on the National Register of Historic Places, resulting in the dedication of the Forest Hill Historic District. A founder of the Forest Hill Historic Preservation Society, she served as its first president and, in 1989, developed and led the first walking tour of historic sites associated with the Rockefeller Estate, now found in Forest Hill Park. She has given numerous presentations on Forest Hill and most recently served as chairperson of the East Cleveland Historic Preservation Board. Gregor holds a master's degree in Urban Studies from the Levin College of Urban Affairs, Cleveland State University.

INTRODUCTION

It has been almost 70 years since John D. Rockefeller made his final journey back to Cleveland. He died on May 23, 1937, just short of his 98th birthday, at his winter home in Ormand Beach, Florida. The funeral service was held at Kykuit, the baronial mansion north of New York City built for him by his son John D. Rockefeller Jr. in 1913. He was laid to rest, however, in the family burial plot at Lake View Cemetery in Cleveland, only a short distance from Forest Hill, which had been the family's country estate and much-loved summer home for four decades.

The fascination with Rockefeller, as in his lifetime, has not diminished over the years. Numerous biographies, articles, documentaries, and recent exhibits have explored his immense wealth and relentless acquisition, industrial genius, brilliant business mind, and managerial skill. The enigmatic and inscrutable public person with nerves of steel and unwavering focus continues to be scrutinized—and the unprecedented philanthropy still serves to inspire.

It would not be an overstatement to say that the roots of the Rockefeller fortune and dynasty are to be found in Cleveland, and that those roots stretched from the oil-drenched banks and murky flats of Kingsbury Run where it emptied into the Cuyahoga River to the wooded sanctuary at Forest Hill. John D. Rockefeller was born on July 8, 1839, on a farm in Richford, New York, in Tioga County about 15 miles from Ithaca. In 1853, the family moved from New York to northeast Ohio and to another small farming community, Strongsville, part of the Connecticut Western Reserve. This was not uncommon, as generations moved out of New England and New York State and migrated ever farther west. That fall, John and his brother William were sent to Cleveland to attend Central High School. They lodged at a boardinghouse on Erie Street (East Ninth). Following a business course at Folsom's Commercial College in the summer of 1855, Rockefeller began a determined search for a job in Cleveland. At the age of 16, he found his first employment (as he later wrote, his "first and only situation") as a bookkeeper in the wholesale produce commission house of Hewitt and Tuttle. The date was September 26, 1855. It was a date he would mark and an anniversary he would celebrate for the rest of his life.

Even though Rockefeller was not exactly a hometown boy, he considered Cleveland home. In the ensuing years, before establishing legal residence in 1884 in New York City, he married Laura Celestia Spelman, a Cleveland schoolteacher and Central High School classmate. His children were all born and raised in Cleveland. He owned three homes over the years and acquired vast amounts of property throughout the city and East Cleveland Township. Here he laid the foundation of a financial and industrial empire, established a commitment to charitable giving and philanthropy, and devised a corporate structure the likes of which the world had never seen.

In 1859, on the eve of the Civil War, Rockefeller left the employ of Hewitt and Tuttle and went into business for himself. He, as the junior partner, and Maurice B. Clark formed the merchant commission house Clark and Rockefeller. The firm also dealt in produce, seed and farm implements, and such items as grain, hay, meat, salt, and mess pork—commodities that would feed and provision an army on the move. The year 1859 also turned out to be an auspicious one for an entirely different reason. The discovery of oil in northwestern Pennsylvania's Titusville set off a wild rush to the oil fields not far from the Ohio border and created a boom likened to the gold fever in California 10 years earlier. Into this frenzied, highly speculative, and literally volatile world Rockefeller first ventured in 1863. Rockefeller's commission house invested half of the working capital in a refinery, the Excelsior Oil Works, one of the 20 to 30 refineries that had sprung up in the flats along the Cuyahoga River. Cleveland emerged from the Civil War an industrial contender, positioned and destined to become a leader in the industrial revolution. Cleveland's location on Lake Erie—between the iron ore ranges in Michigan's Upper Peninsula and later the great Mesabi Range in Minnesota, and the oil fields and coal deposits of Pennsylvania, West Virginia, and Ohio's Mahoning Valley—was fortunate and eventually proved to be geographically strategic. By 1875, five major rail lines converged in the city. As a port at the juncture of the Cuyahoga River, Kingsbury and Walworth Runs, and the northern terminus of the Ohio and Erie Canal, Cleveland became the center of an important transportation network in the Midwest. The wartime economy had brought prosperity to its merchants and bankers and spurred expansion and growth.

Cleveland's increasingly diverse population doubled in the decade from 1860 to 1870, when it reached over 92,000. Elegant homes and lavish mansions had been built along and ever farther out Euclid Avenue, which was known throughout the Union as "one of the finest streets the United States," according to an 1875 edition of the *Cleveland Leader*. These homes on "Millionaires' Row" would house inventors, bankers, and future captains of industry. The proximity and density of Cleveland's entrepreneurs, businesses and industries, and working-class neighborhoods created a vital, thriving urban environment. The mercantile economy was about to change, and the city would be transformed. The economist Alfred Marshall would have recognized that something "was as it were in the air." It was, in no small measure, confidence and courage, for in 1865 Rockefeller sold his share in the produce commission house and entered the business of refining and selling crude oil. He bought outright the Excelsior Oil Works. And in 1870, with partners Henry M. Flagler, Samuel Andrews, Stephen V. Harkness, and William Rockefeller, he founded and incorporated the Standard Oil Company. The rest as they say is history. Or is it?

Surprisingly, in all of the literature about John D. Rockefeller there is little mention, if any, of Forest Hill. We are told it was the home he and Laura loved most of all and that originally Forest Hill was considered a business investment for the establishment of a hotel, water cure, and resort. Indeed, Rockefeller purchased three parcels of land, a total of 103 acres, in 1873 not far from Lake View Cemetery in East Cleveland Township. All three parcels fronted on Euclid Avenue between Lee Road and Superior Avenue, known as the Shaker Road. The largest of the three parcels contained 79 acres, which Rockefeller bought on June 2, 1873, for $79,247 from the real estate syndicate Herrick, King, Brooks, and J. G. W. Cowles. The two smaller parcels were purchased from Mary R. and Marcus W. Montgomery and from Garrett Stafford.

Meanwhile, another venture was unfolding. The progress of this enterprise had been followed and well covered in the daily newspapers, and in February 1874, the *Cleveland Daily Herald* reported the organization of the Lake View and Collamer Railroad Company. The incorporators, including Rockefeller, president William West, secretary Marcus W. Montgomery, and Liberty Holden, trustee of Lake View Cemetery and future owner of the *Cleveland Plain Dealer*, either owned or purchased land along the right-of-way. Rockefeller had earlier purchased three and a half acres across from Lake View Cemetery and sub lots in the housing allotment at Lake View Avenue and Superior Avenue. And in 1875, according to the *Cleveland Leader*, Rockefeller and Stephen V. Harkness donated an acre of land for shops and a roundhouse from the 71-acre triangular-shaped lot that stretched from Collinwood's Five Points to Euclid Avenue along present-day Ivanhoe Road.

On June 24, 1874, Rockefeller actually sold only 10 acres out of the 79-acre parcel at Forest Hill. The narrow sliver of land was placed in Mary R. Montgomery's name. Her husband, Marcus W. Montgomery, must have been able to immediately start building the hotel and sanitarium on the top of the hill, because on the very same day that Rockefeller sold the 10 acres to Montgomery, he dedicated Grove Street, a 597-foot road from Euclid Avenue to the site. As the construction progressed, a group of backers was pulled together, and on April 17, 1875, the *Cleveland Leader* reported the incorporation of the Euclid Avenue Forest Hill Association. It was capitalized at $250,000, the same amount as the Lake View and Collamer Railroad. Less than three months later, on July 5, Marcus W. Montgomery, who listed his residence in the 1875 City Directory as Forest Hill, placed an advertisement in the *Cleveland Leader* that the "beautiful, Summer, Boarding and Health Resort situated within forty minutes ride of the Public Square, upon an eminence overlooking this city" was "now open for business." An article on the same page described the location as "one of the most romantic and delightful spots conceivable with every room in house overlooking a grand expanse of greenery."

It is little wonder that when Rockefeller regained ownership of the 10-acre property, the family fell in love with Forest Hill. Even after Laura died in 1915, Rockefeller continued to return to their summer home. He was at Forest Hill in the fall of 1917, having delayed his departure east, and being interviewed for a biography by newspaperman William O. Inglis. He managed to celebrate at Forest Hill, that beautiful and fateful autumn, the September 26th anniversary of his first employment. He sent a cake marked "1855" to his son and daughter-in-law Abby Aldrich Rockefeller. Then, two months after the residence had been closed for the winter, Forest Hill burned to the ground. Perhaps because so many records, mementos, and photographs perished in the disastrous fire on the night of December 17, or perhaps because the chronicle and the retelling of Rockefeller's life is eclipsed by the labyrinthine story of the oil industry, Forest Hill remains today as shrouded in secrecy as it did during his lifetime. In fact, the Rockefellers had been summer residents of the city of East Cleveland for almost 40 years.

When the home was destroyed, one metropolitan newspaper lamented "a community loss" of a landmark. For decades, the name Forest Hill had evoked in Cleveland and elsewhere curiosity, mystery, and imagination. For here, six miles east of downtown and Public Square, resided one of the most famous families in America. From the late 1870s to 1917, the fabled country estate and summer home had secluded the Rockefellers from a burgeoning industrial city and the outside world. One thing is certain: Forest Hill was incredibly beautiful.

Due to its rugged nature, the property first acquired by Rockefeller in the 1870s had to be one of the few stretches of land in East Cleveland Township from Lake View Cemetery to Euclid Creek that had not been cleared for a farm, homestead, orchard, or vineyard. The land rose in a series of ridges or terraces from Euclid Avenue to a plateau on the heights above. It was crossed by two brooks—the east branch of Dugway Brook and a lesser branch, which was eventually called Rockefeller Brook. Both of these waterways had cut steep ravines into the escarpment and created wide valleys as they flowed northward toward Lake Erie. As more and more property was purchased over the years, in a long series of often complex land transactions, Forest Hill evolved and changed into a landscaped and cultivated summer home with a formal rose garden, greenhouses, a lake and lily pond, a horse track, and miles of perfectly raked, meticulous gravel roads. It was also a working estate in the tradition of an English country home with farmland, livestock, barns, pastures, and tenant houses. Eventually the estate and residence west of Lee Road were completely enclosed, and in another comparison to a landed country estate, it is striking how often the grounds within the enclosure were referred to as "the Park."

In the early 1900s, tourists and residents alike made their way by streetcar out Euclid Avenue, past the Rockefeller townhouse on Millionaires' Row at Case Avenue (East Fortieth), beyond Rockefeller Park near University Circle, and past Lake View Cemetery to the city of East Cleveland. Here it was possible to peer through the imposing iron fence and huge gates scrolled with the letter *R* and view the gatekeeper's lodge, the manicured lawns, and the gravel carriage road that led out of sight into the thick woodlands and to the mansion high atop the hill

above Euclid Avenue. This was such a popular destination and attraction that souvenirs were sold in Cleveland. One could buy a china cup, saucer, or small bowl that had been made in Bavaria and decorated with a picture of the gatehouse. Or it was possible to choose from one of many postcards depicting a variety of scenes of the estate: the gatehouse, the lake, the rambling Victorian mansion, the Rockefeller monument in Lake View Cemetery, or the picturesque lagoon in Rockefeller Park. Each one provided only a glimpse of the "richest man in America."

Very few people had an invitation in Rockefeller's lifetime to visit Forest Hill or play golf on its legendary course. This book will open those gates and tell the story of the land, its evolution over the years, and its continuing legacy. These pages will also allow views of some of the Cleveland landmarks associated with John D. Rockefeller and the farms, homes, churches, businesses, and schools along the perimeter of the estate that would have been familiar to the Rockefeller family. Let us begin.

One

THE ROCKEFELLER ESTATE
1873–1923

In the early 1870s, John D. Rockefeller began to make considerable investments in land, not only in Cleveland but beyond the city limits to the east, past Wade Park, and into rural East Cleveland Township. Within three years of founding the Standard Oil Company and having already set his sights on acquiring and consolidating the many oil refineries in Cleveland into one large combination, Rockefeller also became part of two very ambitious, well-planned, and related ventures. One was the organization and construction of a short line railroad, the Lakeview and Collamer Railroad Company, and the other would be called Forest Hill. In both of these business enterprises Rockefeller served as one of the incorporators, and for both he provided strategically situated land.

In retrospect, the timing could not have been worse. Both ventures failed. A financial panic had occurred in September 1873 during Grant's second administration, one of the panics that periodically swept the country. This one, set off by the collapse of the banking house of Jay Cooke and Company and an over-expanded economy, did not go away. While newspapers called for calm, the panic turned into a depression that lasted through the decade. The county tax duplicates for East Cleveland Village tell the story of one delinquent property after another, including those of Marcus W. and Mary Montgomery and the 10-acre hotel and sanitarium at Forest Hill. In October 1876, Mary Montgomery filed for bankruptcy. The long list of creditors clearly indicates that a very large structure had been built at Forest Hill. Among the names of carpenters, plumbers, builders, lumber dealers, gas and steam fitters, and manufacturers of stoves, tin ware, and lightning rods were the names of firms recognizable today: the Kelley Island Lime Company, George Worthington and Company, and Sherwin, Williams, and Company. The inclusion of the American Telegraph Company suggests that as early as 1875 a telegraph wire had been installed at Forest Hill. And the very first name at the top of the list of creditors was John D. Rockefeller. On July 3, 1877, at a private sale, he submitted the highest bid and best offer for $23,000 and bought back Forest Hill.

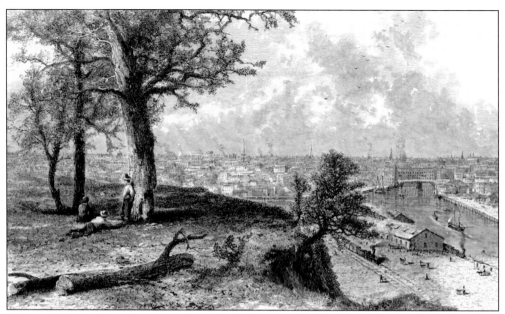

This *c.* 1874 view from *Picturesque America* looks across the Cuyahoga River and the Flats from Scranton's Hill to a city whose economy by 1870 had been changed by the Civil War and whose air was filled with smoke and the smell of oil. Already there were signs of its population moving east, with the establishment of a hotel and water cure called Forest Hill in East Cleveland Township.

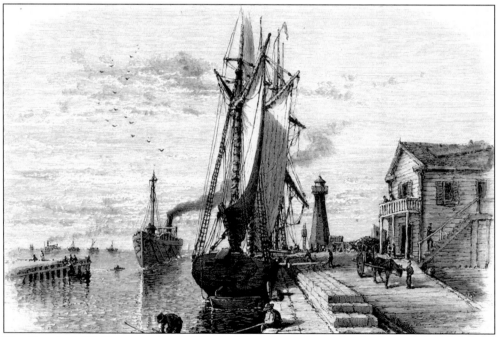

The Standard Oil Company, located in the Flats, shipped its refined oil to other major cities on the Great Lakes and in Canada. This view, also from *Picturesque America*, shows a busy Cleveland port at the mouth of the Cuyahoga River. Vessels and lake schooners are lined up in Lake Erie as a mighty steamer enters the Cuyahoga River, perhaps bound for Kingsbury Run.

THE CITY.

Important Meeting.

There will be a special meeting of the Young Ladies' Temperance League, to transact important business, in their house, No. 213 Erie street, Tuesday morning, July 6th, at half-past ten. All interested in the work are requested to be present.

Knights of Pythias.

At a meeting of Washington Lodge No. 10, Knights of Pythias, the following officers were lately installed by D. D. G. C. W. B. Rich:

P. C.—C. V. Green.
C. C.—J. F. J. Davis.
V. C.—William K. Radcliff.
Prel.—C. H. Balore.
Mal. A.—A. B. Beach.
L G—William Freeman.
O. G.—D. W. Harrison.

Accidents.

Joseph Smith, aged ten years, and living at No. 492 St. Clair street, met with a singular but severe accident, Saturday, while riding in a wagon on that street. In some way one of his feet got caught in a wheel to the wagon by which the bottom of the foot was mangled in a fearful manner and nearly all the flesh torn off. The unfortunate lad was taken home at once and Dr. Perriere called, who dressed the wound.

George Prindeville, about sixteen years old, was amusing himself on the lake shore, Saturday, when he fell, breaking his right thigh bone. He was taken to his home, No. 360 Hamilton street, where Dr. House attended him and set the bone.

Forest Hill.

The new resort for health and recreation, known as "Forest Hill," has already been noticed in the columns of the LEADER, and the date of opening announced. This date was the 28th ultimo and the house is, therefore, now open for the reception of guests. Located in one of the most romantic and delightful spots conceivable, with everything arranged for the comfort and accommodation of visitors, with every room in the house overlooking a grand expanse of scenery and with the management all that could be desired, "Forest Hill" is certainly destined to become popular with the best classes of health and pleasure seekers so soon as its attractions are known.

Burglaries and Thefts.

Some unknown person broke a glass from a window in No. 55 Garden street, Saturday night, and stole a pistol valued at $8.

Frank O'Rourke was arrested on Saturday night on a charge of picking between one and two dollars' worth of property from Julius Wolf's pocket while they were in a saloon on Cedar avenue.

Patrick Ball, living at No. 6 Murison street, says a coat worth $7 was stolen from him

and Mechanical College, Columbus, Ohio; Prof. Edw. S. Morse, Salem, Mass.; Prof. J. Tingley, Allegheny College, Meadville, Pa.; Dr. E. Sterling, State Fish Commissioner, Cleveland.

Dr. Burt G. Wilder, from whom a lecture was expected, will be unable to appear on account of conflicting engagements. Dr. J. S. Newberry will deliver some geological lectures, if not called away from the city by business.

Below is given, with their registered numbers, a list of

APPLICANTS ACCEPTED:

1. Prof. John Bolton, Central High School, Cleveland.
2. George W. Coon, teacher, Cleveland.
3. F. L. Rich, Cleveland.
4. Charles Gale, Cleveland.
5. George F. Smythe, teacher, Western Reserve College, Hudson, O.
6. Miss M. H. Gale, teacher, Rockwell Street School, Cleveland.
7. Miss Hughes, Principal Rockwell Street School, Cleveland.
8. Mrs. A. A. Hard, Cleveland.
9. John S. White, Master Brooks School, Cleveland.
10. J. G. Gehring, Cleveland.
11. Mrs. John S. White, Cleveland.
12. Prof. Alex. Forbes, Principal Normal School, Cleveland.
13. Miss Charity Dye, teacher, Indianapolis, Ind.
14. Miss Hattie Galentine, Cleveland.
15. Miss Rachel Clyne, Cleveland.
16. E. E. Phillips, teacher, Berea, Ohio, (withdrawn).
17. Frank Klepetko, assistant in Cleveland Library.
18. Miss Ella Trout, teacher in High School, Canton, Ohio.
19. Miss Bettie Wear, teacher, Indianapolis, Indiana.
20. W. R. Comings, Superintendent of Instruction, Medina, Ohio.
21. Miss Rose Dark, teacher, Indianapolis, Indiana.
22. B. T. Stafford, Cleveland (withdrawn).
23. Miss Joanna Dissette, teacher, Cleveland (withdrawn conditionally).
24. Miss Mary Leonard, teacher, Indianapolis, Indiana.
25. F. J. Barnard, teacher, Brooklyn village, Cuyahoga county, Ohio.
26. Errick Rossiter, Cold Spring, Putnam county, N. Y.
27. W. J. Green, teacher, Granger, Medina county, Ohio.

There is still a chance for a few more applicants, if their names are registered before Tuesday, although it will be necessary for the Board of Instruction to act upon all names received after to-day. A very few course tickets to the lectures will be issued to such as are unable to attend in the laboratory, but these can only be obtained by the special consent of the Board of Instruction. The price is five dollars.

Every dollar that can be added to the funds at the disposal of the managers will be used to the very best advantage. If it were really known how much has been accomplished with a very trifling expenditure, the public would be astonished at the zeal and perseverance which has surmounted so many obstacles. Were it not for the generous self-sacrifice of all the instructors in giving their services without pecuniary compensation, merely for the love of their work and the good it will accomplish, it would be impossible to conduct the school for a single day. It is trusted that the citizens will remember this fact and show these gentlemen that their labors are not wholly unappreciated.

IN MEMORIAM.

Resolutions Adopted in Honor of the Late Father Williams, and John Gundry.

The following resolutions of respect were adopted by Cleveland Division No. 275, Sons of Temperance, to the memory of John R.

The July 5, 1875, article in the *Cleveland Leader* announcing the opening of Forest Hill was a ringing endorsement from Cleveland's leading newspaper and its influential owner, Edwin Cowles. The paper predicted that "Forest Hill is certainly destined to become popular with the best classes of health and pleasure seekers" and declared that it was "located in one of the most romantic and delightful spots conceivable, with everything arranged for the comfort and accommodation of visitors, with every room in the house overlooking a grand expanse of scenery." (Courtesy of the Cleveland Public Library.)

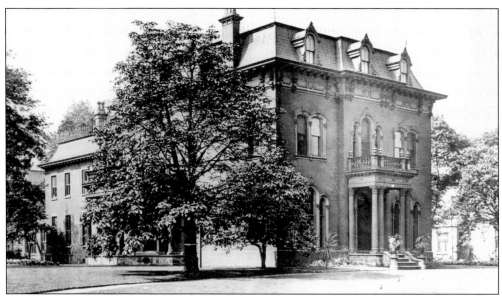

John D. Rockefeller purchased the mansion at 997 Euclid Avenue, near the corner of Case Avenue (East Fortieth), from Francis Keith in 1868 for $40,000. Designed by Cleveland architect Simon Porter, the home boasted an imposing portico, floor-to-ceiling hooded windows ornamented with stone, and a broad cornice below a mansard roof, in vogue on Millionaires' Row. In 1879, Rockefeller bought the corner house from Levi Burgert and moved it one block to Prospect Street, doubling the size of his townhouse property. (Courtesy of the Western Reserve Historical Society.)

With the founding of the Standard Oil Company in 1870, Rockefeller gained control of the industry and Cleveland dominated the market into the 1880s. Seen here in 1889, Refinery No. 1 sprawls over the slopes and banks of Kingsbury Run with its storage tanks for refined oil, crude tanks, distilling bleachers, distillate tanks, and barrelhouses. It was a dangerous business—especially in the early years—as there was a constant threat of fire. (Courtesy of the Western Reserve Historical Society.)

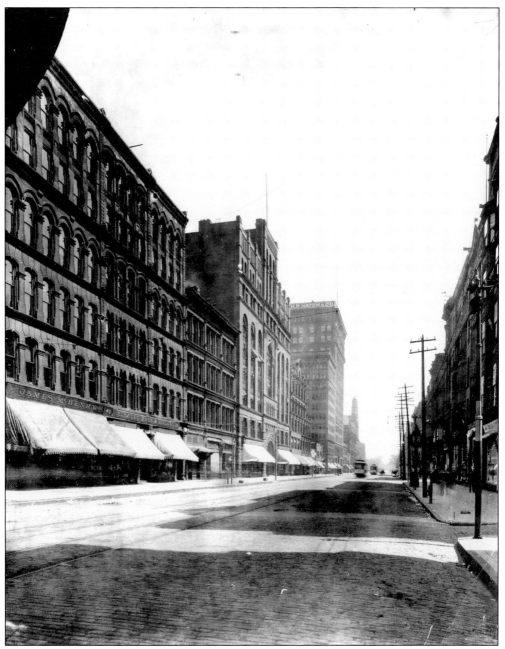

In 1873, John D. Rockefeller and his partners built the Standard Block on the north side of Euclid Avenue across from Sheriff Street (East Fourth). It served as the Cleveland headquarters of the Standard Oil Company until 1907. The six-story structure (left), with commercial shops at street level and offices on the upper floors, was the largest building on Euclid Avenue until the magnificent Arcade, shown here in the 1890s, was built one block east by Rockefeller's partner, Stephen V. Harkness, in 1890. By then Cleveland's buildings of commerce and industry no longer occupied just the Flats or the warehouse district west of Public Square, but were being built along Euclid Avenue, replacing its homes and mansions as far as Erie Street (East Ninth), visible in the distance. (Courtesy of the Western Reserve Historical Society.)

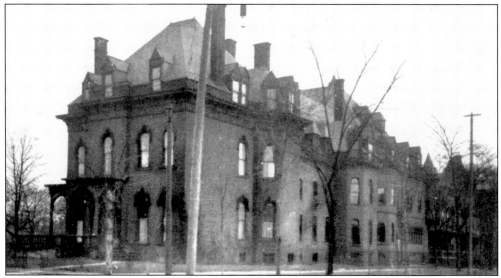

Over several weeks, the Burgert mansion was inched on rollers to the southeast corner of Case Avenue (East Fortieth) and Prospect Street. John D. Rockefeller then leased the house to Augusta Mittleberger, who ran it as a private boarding school until her retirement in 1909. Not only was the school attended by young women and girls from some of Cleveland's most prominent families, but also by President Garfield's and President Hayes's daughters.

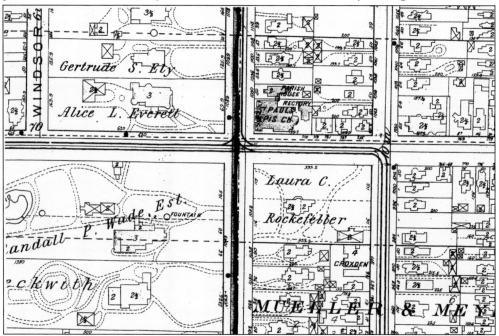

The 1898 atlas *City of Cleveland Ohio* by A. H. Mueller and Company shows the Rockefeller townhouse, which was placed in Laura Rockefeller's name in 1874, on the southwest corner of Euclid and Case Avenues. Across the avenue are the mansions of the Beckwith, Wade, Everett, and Ely families. On the southeast corner are St. Paul's Episcopal Church, rectory, and parish house. The two-and-a-half-story structure one block behind St. Paul's is Augusta Mittleberger's School. (Courtesy of the Cuyahoga County Archives.)

St. Paul's Episcopal Church was built
in 1875. Designed by Gordon W. Lloyd
in the High Victorian Gothic style,
the church was sold to the Cleveland
Catholic Diocese in 1931 after the parish
of St. Paul's Episcopal Church moved to
its present location at Coventry Road
and Fairmount Boulevard in Cleveland
Heights. The church, which now serves
the community of St. Paul Shrine, is one
of the few Millionaires' Row structures left
on Euclid Avenue.

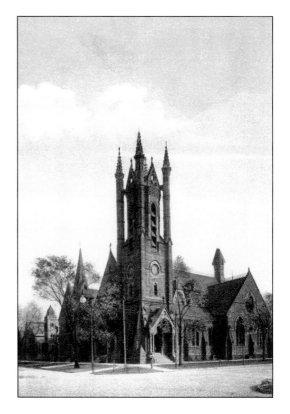

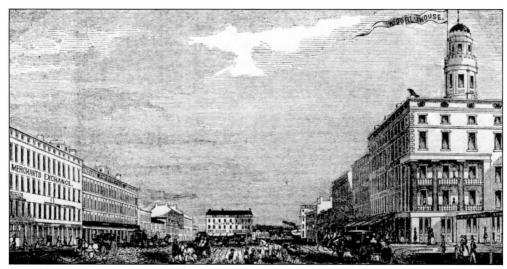

In 1874, the promoters and incorporators of the Lake View and Collamer Railroad met at the
Weddell House, located on the corner of Superior Avenue and Bank Street (West Sixth), as
they organized their new rail line. The hotel was not far from Marcus W. Montgomery's office
on Superior Avenue or John D. Rockefeller's new Standard Block on Euclid Avenue. This 1846
print from *Howe's Historical Collection's of Ohio* is an early view of Superior Avenue. In 1861,
Abraham Lincoln spoke from the balcony of the Weddell House on the way to his inauguration
in Washington, D.C.

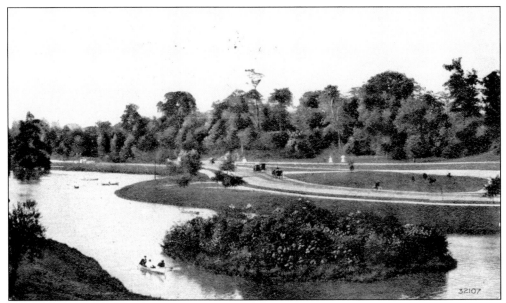

Rockefeller Park is probably the most well-known gift of John D. Rockefeller to the City of Cleveland. In 1896, the parcels of land were secretly assembled at a cost of $628,000 by Rockefeller's real estate agent, J. G. W. Cowles; underwritten by Rockefeller; and presented to the city during its centennial celebration.

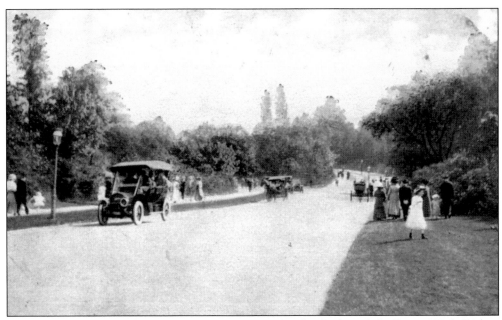

The parkway Martin Luther King Jr. Drive connects Gordon Park on Lake Erie to Wade Park at University Circle and follows the course of Doan Brook. John D. Rockefeller added to the gift a donation for the construction of a bridge to carry traffic across Superior Avenue. The vaulted bridge is not far from the site of the long-forgotten trestle from Rockefeller's early venture, the Lake View and Collamer Railroad.

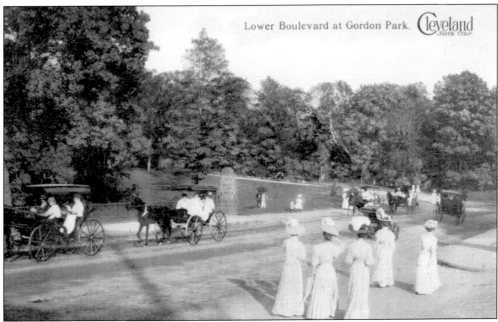

In the 19th century, Gordon Park had many features of an Olmsted-designed park: a large lawn pasture, a green, a ramble, and curved pleasure drives. Formerly the landscaped private estate of William J. Gordon, the park was given to the City of Cleveland, as directed by Gordon's will when he died in 1892.

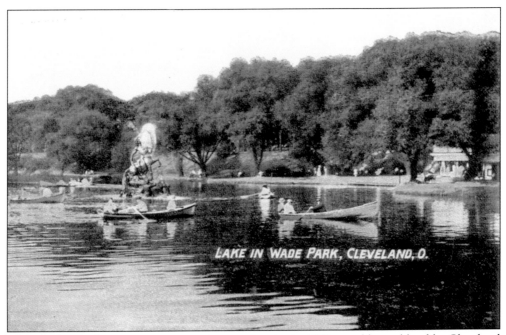

LAKE IN WADE PARK, CLEVELAND, O.

Wade Park was also a private estate, given to the city in 1882 as public parkland by Cleveland financier, industrialist, and civic leader Jeptha H. Wade. It was the site of the city's first zoo. Its lake with fountain and boathouse, the present lagoon in front of the Cleveland Museum of Art, remains one of Cleveland's loveliest spots.

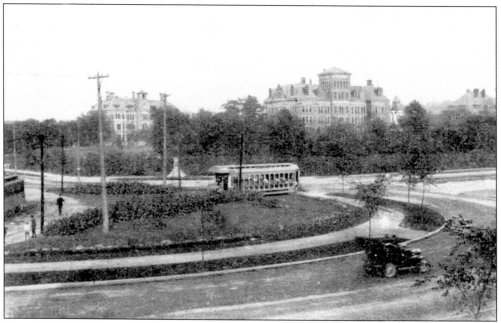

John D. Rockefeller would have traveled through University Circle innumerable times from Forest Hill to his townhouse at 997 Euclid Avenue, his offices in the Standard Block, and the Euclid Avenue Baptist Church at Huntington Street (East Eighteenth). He would have witnessed its change from Doan's Corners to the site of two major universities in the 1880s, the Western Reserve Historical Society in 1898, and the Cleveland Museum of Art in 1916.

In 1871, John D. Rockefeller purchased three and a half acres of land across from Lake View Cemetery from Liberty E. Holden. The lot was not far from the Forest Hill property Rockefeller would buy two years later or his investments on Superior Avenue. The land across from the cemetery, between Lake View Avenue and today's East 123rd Street, became commercial and industrial and the site of the F. B. Stearns Company automobile factory. (Courtesy of Lake View Cemetery Association.)

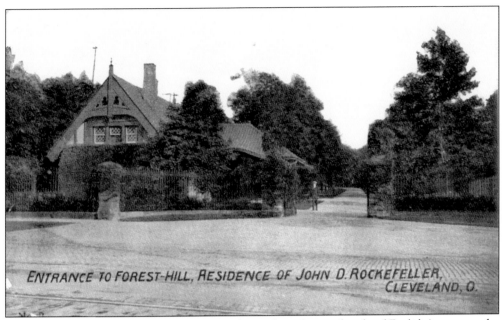

ENTRANCE TO FOREST-HILL, RESIDENCE OF JOHN D. ROCKEFELLER, CLEVELAND, O.

The gatehouse to the Forest Hill estate was located on the south side of Euclid Avenue at the present intersection of Forest Hills Boulevard. It was constructed about 1904 and appears on many different postcards. Resembling a hunting lodge, the gatehouse was indeed called the Lodge. Its gatekeeper, Patrick Lynch, who lived there with his brother Edward, became almost as well known and photographed as his famous employer.

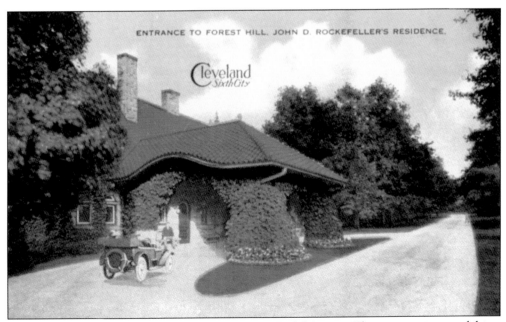

ENTRANCE TO FOREST HILL, JOHN D. ROCKEFELLER'S RESIDENCE.

The Forest Hill estate actually had an address: 13652 Euclid Avenue. The main carriage road drive, which had been Grove Street when the hotel opened in 1875, began at the gatehouse and curved out of sight, making a slight ascent toward the orchard, gardens, greenhouses, and lily pond.

There are enough references and surviving photographs of the lily pond to know that it was a beautiful and well-known feature of the estate. It was fed by water from Rockefeller Brook, which flowed down the east ravine, continued behind the gatehouse, and ran under Euclid Avenue. This rare photograph of the lily pond in winter is dated February 28, 1927. Its shape and the surrounding terrain are unmistakable. (Courtesy of Ted Frost.)

The gardener's house was located on the plateau between today's Belmore Road and Forest Hills Boulevard, the present site of Huron Hospital. It faced Belmore Road and, according to maps, was at one time much closer to the street. By 1926, it had been moved back next to the Vassar Road gate. A long road to the right of the house, lined with towering trees, ran down the middle of the orchard and gardens. (Courtesy of the Rockefeller Archive Center.)

This photograph, taken between 1924 and 1927 in the vicinity of the main carriage road drive, shows the meticulous care still given to the estate even after the residence was gone. John D. Rockefeller loved scenery and landscaping. He oversaw and planned, through his superintendents at Forest Hill, the maintenance of his estate, the laying out of roads, the planting of crops and trees, and the landscaping of scenic views. (Courtesy of Ted Frost.)

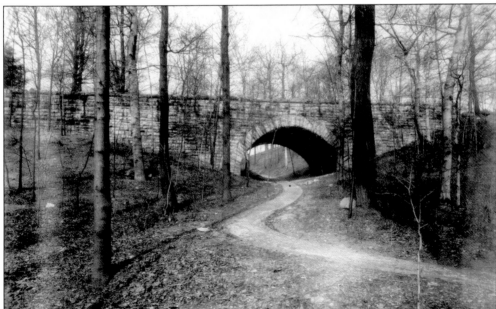

From the lily pond, the main drive crossed in front of and below the mansion and started up the ridge of the Dugway Valley to the residence. Pictured here is the main carriage road bridge, with its rustic hewn sandstone construction and parapet railing. It was the largest of over 20 bridges on the estate and one of only three that still exist. (Courtesy of the Rockefeller Archive Center.)

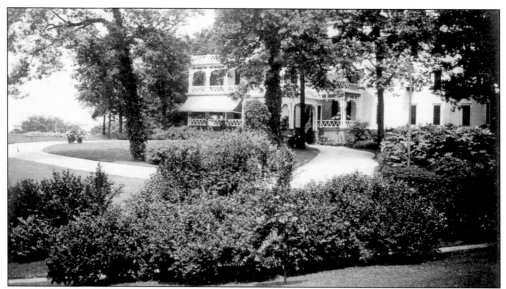

John D. Rockefeller changed the entrance of the residence and added the porte cochere over the driveway to shelter the carriages. This could not have been accomplished until after 1878, when he acquired the Rowe property, which fronted on Euclid Avenue and Superior Street and gave Rockefeller access to the Dugway Valley approach to the mansion. (Courtesy of the Rockefeller Archive Center.)

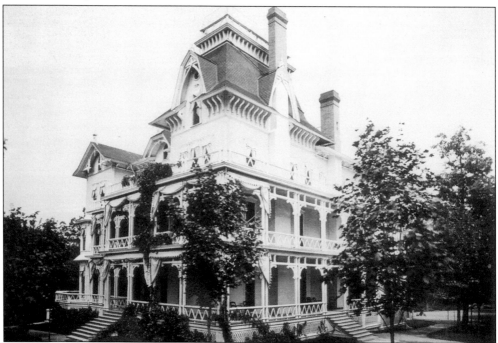

The residence seems to defy architectural description with its array of verandas, porches, windows, brackets, gingerbread, and mansard-roofed tower. But Victorian America loved it. Forest Hill was part of the Gothic—and particularly the Carpenter Gothic—Revival that swept the country in the 1800s; this style can still be found in summer communities throughout the country. (Courtesy of the Rockefeller Archive Center.)

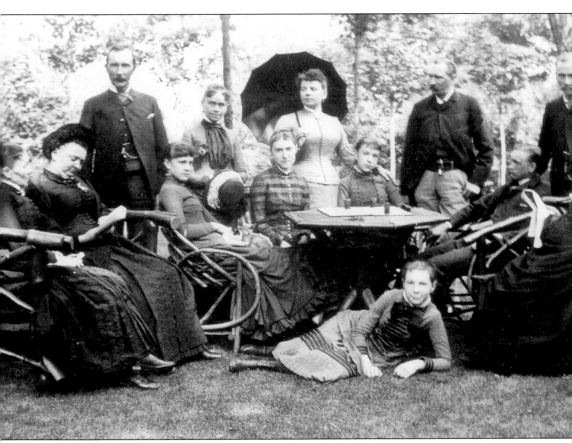

John D. Rockefeller Jr. took this photograph at Forest Hill around 1881, when he was seven years old. Pictured here, from left to right, are the following: (first row) his mother, Laura Celestia Rockefeller; Ellen J. Foster, a temperance worker; cousin Florence Briggs Benjamin; sisters Bessie and Edith; Felix Arnold; and grandmother Lucy Henry Spelman; (second row) his father, John D. Rockefeller; aunt Lucy Spelman; Mrs. Richard Arnold; Richard Arnold, his violin teacher and the concertmaster of the New York Philharmonic Orchestra; and George Rogers, his father's secretary. Lying on the ground is his sister Alta. (Courtesy of the Rockefeller Archive Center.)

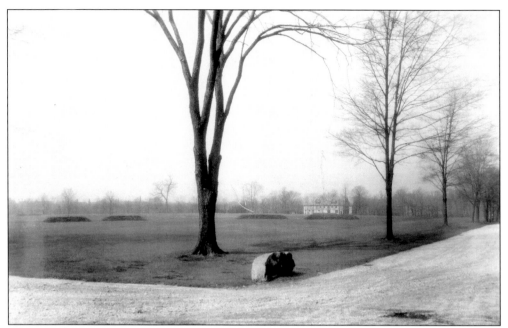

By 1926, when Andrew J. Thomas took this photograph, John D. Rockefeller had not returned to Forest Hill in nine years, yet the golf course was still maintained. Looking to the west toward the barns and stables, this view illustrates why, in 1938, A. D. Taylor called the land "a beautiful expanse of greensward" and designated it the Great Meadow in Forest Hill Park. (Courtesy of the Rockefeller Archive Center.)

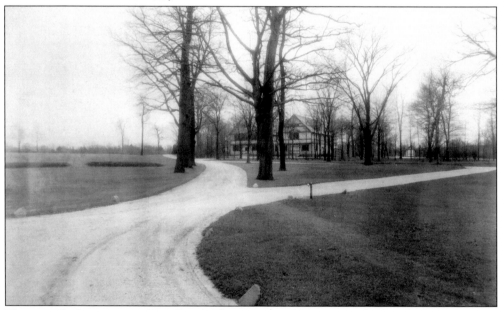

This view looks east toward Lee Road. There is some debate as to whether the legendary golf course had eight or nine holes. The 1925 F. A. Pease Engineering Company map shows only eight holes. When the course was expanded in 1932 as part of the Forest Hill Development, James C. Jones explained to the *Heights Press* that in Rockefeller's time the holes had crisscrossed each other. (Courtesy of the Rockefeller Archive Center.)

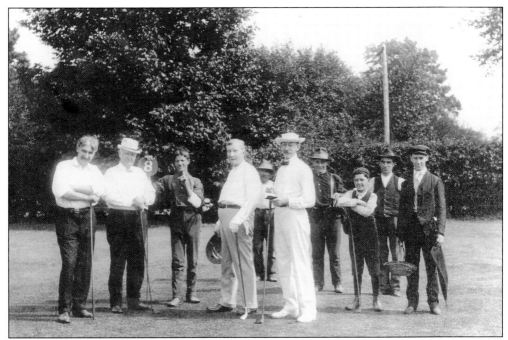

During his summer stay, John D. Rockefeller played golf every day at Forest Hill, often in the worst weather and usually with close and favorite friends. Pictured here about 1907, from left to right, are Rev. Charles Aubrey Eaton, Dr. Hamilton Biggar, Rockefeller, and E. M. Johnson. The large trees, utility pole, and hedgerows identify this spot as one of the greens near Lee Road. Caddies and groundskeepers were always on hand. (Courtesy of the Western Reserve Historical Society.)

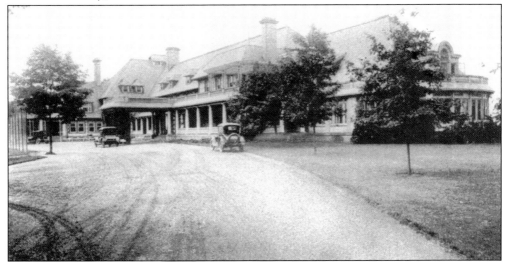

Joe Mitchell, Cleveland's first golf professional, laid out the course at Forest Hill. Mitchell, a Scotch professional, was hired in 1897 by the Cleveland Golf Club and brought to Cleveland by way of the Royal Golf Club in Berlin. He had been giving Laura Rockefeller instructions for about a year when Rockefeller engaged Mitchell to secretly give him lessons as a surprise to his wife. Mitchell was brought to Forest Hill by carriage from the Country Club in Bratenahl, seen here around 1920. (Courtesy of the Western Reserve Historical Society.)

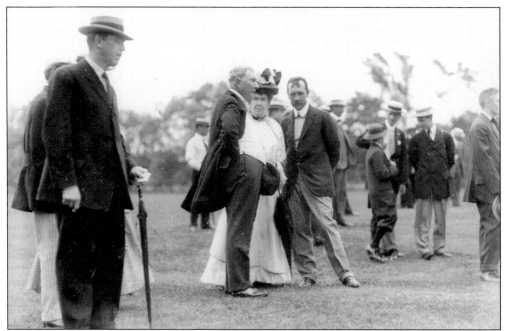

On July 8, 1907, the Euclid Club hosted the National Amateur Golf Championship Tournament. John D. Rockefeller's arrival on the first day of play caught everyone by surprise and brought the tournament to a stop. He was immediately surrounded by reporters and photographers, and when he mentioned that it was his birthday, even the players on the ninth green joined the crowd to shake his hand and offer congratulations. (Courtesy of the Western Reserve Historical Society.)

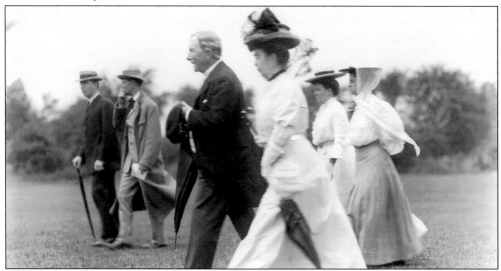

John D. Rockefeller attended the tournament every day, bantering with reporters enthusiastically about golf, following the gallery, even rolling up his gray-striped trousers as he navigated the rougher spots of the course. The upper nine holes had been laid out on land that he owned and had allowed the club to use. Rockefeller pronounced the course "splendid" but volunteered that his Forest Hill greens were in better condition, and that his course at Pocantico Hills, New York, could not be surpassed. (Courtesy of the Western Reserve Historical Society.)

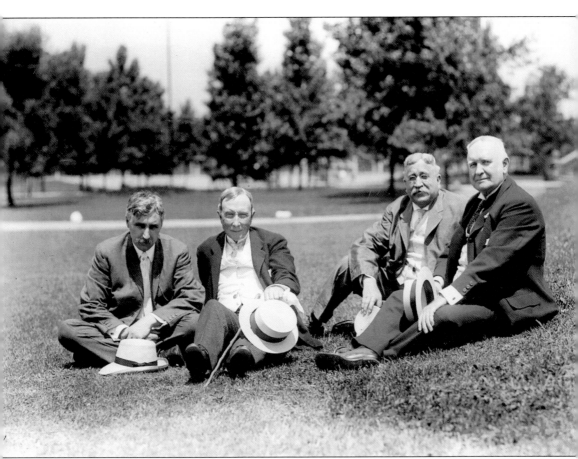

The *Cleveland Press* had a lot of fun with this photograph, labeling it "Four Old Cronies—Do You Know Them?" The answer was a preacher, a doctor, and two merchants who were brothers-in-law, one selling groceries and the other oil. Somehow *Cleveland Press* photographer Louis Van Oeyen got the four to sit on the ground. Pictured here, from left to right, are Rev. Charles Aubrey Eaton, uncle to Cyrus Eaton and pastor of the Euclid Avenue Baptist Church, who served in the House of Representatives from New Jersey from 1924 to 1952; John D. Rockefeller; William C. Rudd, president of Chandler and Rudd; and Dr. Hamilton Biggar of Huron Road Hospital. The Euclid Club, with its balustrade leading to the veranda, can be seen to the far right. By the end of the tournament, Rockefeller was no longer the center of attention. Representing the New York Metropolitan Golf Association, Jerome Travers of Montclair, New Jersey, won the championship. (Courtesy of the Western Reserve Historical Society.)

Given John D. Rockefeller's love of horses, it is not surprising that the half-mile track at Forest Hill was one of the first features laid out. Its kite shape conforms to the narrow stretch of land behind the residence that was part of the 1873 purchase. The two rows of maple trees shown in this 1926 photograph were planted by a young John D. Rockefeller Jr. to provide shade for the walk to the lake. (Courtesy of the Rockefeller Archive Center.)

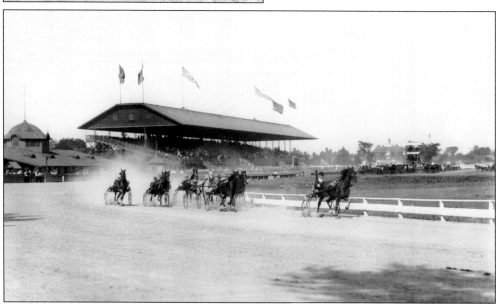

In 1870, the Cleveland Driving Park Company built the Glenville track adjacent to the Northern Ohio Fair Grounds. John D. Rockefeller, an expert horseman and driver of fast trotting horses, maintained a stable at the Glenville track, pictured here around 1900. He employed a trainer, Alexander McLean, who traveled back and forth between New York City and Cleveland and was a familiar sight at both Glenville and Forest Hill as he cared for and worked out Rockefeller's prized trotters. (Courtesy of the Western Reserve Historical Society.)

The lake at Forest Hill was created by constructing an earthen dam across a brook that came down from the heights and flowed through the east ravine of the estate to Euclid Avenue. Across the dam was a carriage road. This view, taken in September 1918 and labeled "Lake Drive," faces south with the lake to the left, the outlet and spillway to the right, and the road curving out of sight to the track. (Courtesy of the Rockefeller Archive Center.)

On either side of the lake drive across the dam were rustic railings on which clematis vines trailed and grew in profusion. One can imagine the scene by standing at the same spot on the bridge at the lake in Forest Hill Park. This view looks to the north, evergreen trees still grow in the ravine on the left. A carriage road once curved below the dam and traveled the east ravine. (Courtesy of the Rockefeller Archive Center.)

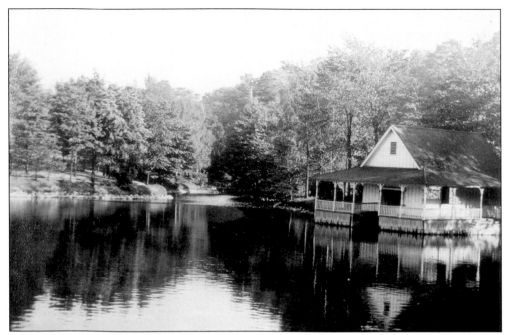

Dated September 1918 and labeled "Boat House," this view looks southeast toward the source or headwaters of the lake. Today the view would be toward Lee Road and Forest Hills Boulevard. A small rustic wooden bridge crossed the inlet in the grove of trees. The boathouse was one of the most charming, picturesque, and photographed parts of the estate. (Courtesy of the Rockefeller Archive Center.)

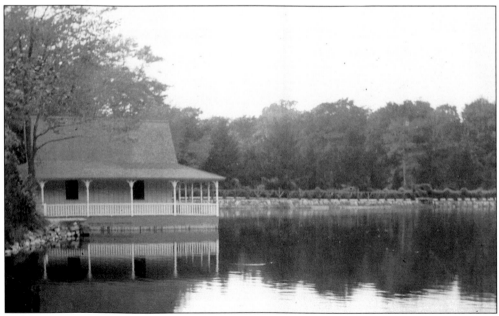

The lake covered four acres and was 15 feet deep. The Rockefeller children learned to row and swim in the lake at Forest Hill. When it froze, the family ice-skated often with large numbers of friends. John D. Rockefeller, an avid ice-skater, had the courtyard of his New York City townhouse converted to a small rink in the winter. (Courtesy of the Rockefeller Archive Center.)

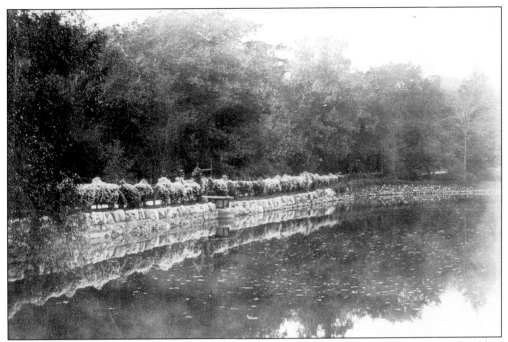

The embankment around the edge of the lake was lined with a retaining wall of large boulders and a walk. The property was purchased from the Lee family in 1881. This photograph, though undated, is labeled "Where the Clematis Blooms" and reveals the outlet of the lake at the approximate site of today's outlet and spillway. (Courtesy of the Rockefeller Archive Center.)

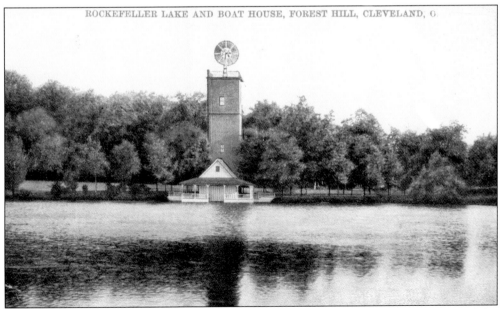

This card is postmarked 1907. The view was taken across the lake, facing south toward the woodlands at the corner of Lee Road and Forest Hills Boulevard. The windmill behind the boathouse is puzzling. In 1938, A. D. Taylor noted an old sand filter about 30 feet in this area, so it is possible that the windmill was part of a filtration system that supplied water for the estate.

By 1925, the City of East Cleveland had started the improvement of Lee Road from the top of the hill near Glynn Road south to the city limits in the distance. This southward view, dated February 18, 1925, shows the estate and the lake on the right enclosed behind wire fence, cement posts, and hedgerows. The Rockefeller farm property is to the left. (Courtesy of East Cleveland Public Library.)

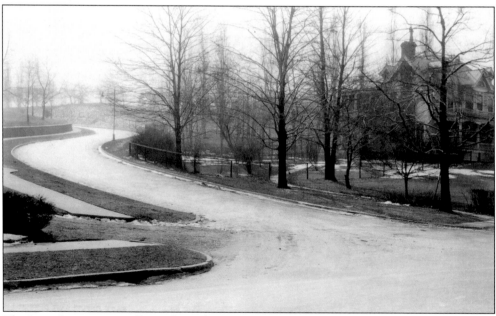

The Lincoln mansion still stands at the southwest corner of Lee and Terrace Roads. It was built on James McCrosky's farmland, which extended up the hill. He allotted his property and vineyards in 1895 and 1905 and dedicated Wymore Road and Collamer Terrace. The Rockefeller estate is to the right, behind the home. Dated February 18, 1925, this photograph was taken from the first location of the A. M. McGregor Home. (Courtesy of East Cleveland Public Library.)

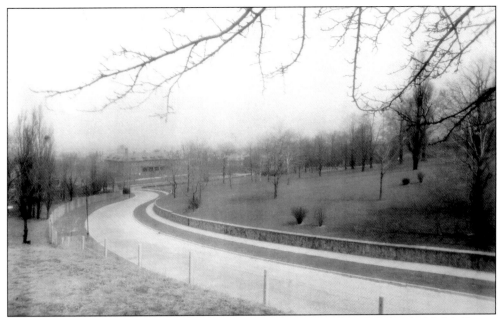

Sisters Sophia Barber McCrosky and Tootie Barber McGregor founded the A. M. McGregor Home in 1904 in memory of Tootie's husband, Ambrose M. McGregor. He had been one of John D. Rockefeller's most trusted employees and loyal officers. He rose to the position of president of Standard Oil of Ohio. In 1941, the A. M. McGregor Home moved to the hill property on Private Drive, and in 2005, the retirement community completed an impressive building program. (Courtesy of the Rockefeller Archive Center.)

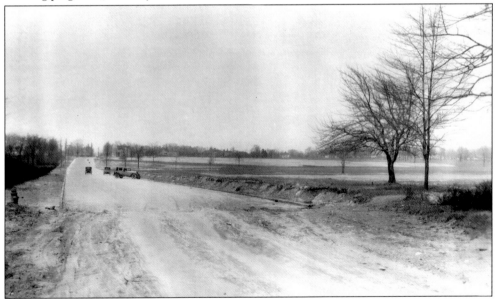

By 1926, Lee Road in East Cleveland had been widened, paved, and improved with a sewer system to the city limits. Andrew J. Thomas took this photograph from the East Cleveland/Cleveland Heights city line looking north. The Rockefeller lake is behind the hedgerows to the left, Glynn Road is in the distance, and a part of the proposed Forest Hill Development is to the right. (Courtesy of the Rockefeller Archive Center.)

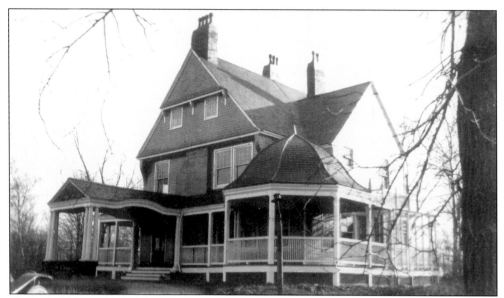

Henry S. Blossom built this Queen Anne–style home in 1890 at the top of the hill at 1900 Lee Road. The hill property had been allotted in 1890 as part of the Grand View Survey. Along the crest on Private Drive, large homes and mansions faced Lake Erie including William B. Chisholm's Thistle Hall. In 1927, the Blossom Home became the residence of Byron A. Bowman, chief construction engineer for the Forest Hill Development. (Courtesy of the Rockefeller Archive Center.)

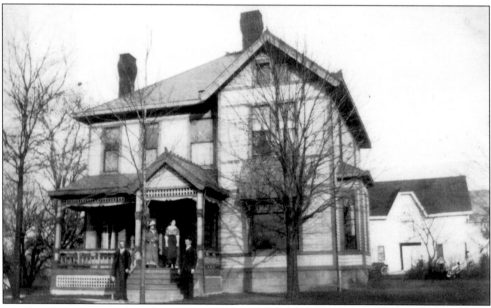

The farmhouse at 1549 Lee Road was not far from Mayfield Road. The building was the office and residence of W. B. Smith, superintendent of the Forest Hill estate. In 1927, it became the headquarters for Andrew J. Thomas and his staff of engineers. Behind the house a quadrangle of barns surrounded a courtyard, and to the north a branch of the Dugway Brook came down from the heights and traveled through a culvert under Lee Road. (Courtesy of the Rockefeller Archive Center.)

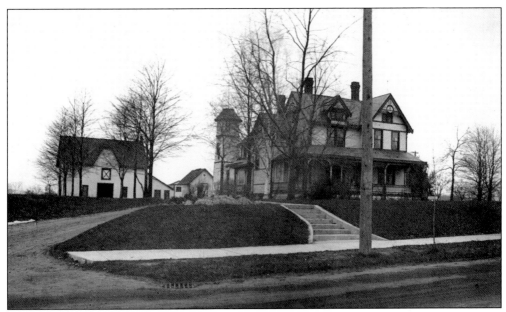

Orville Dean purchased this property at 3151 Mayfield Road in 1886 and operated his well-known dairy business from the location until 1917, when he sold the five and a half acres to the Montifiore Home. He then moved this large Queen Anne–style home several lots to the east, to 3211 Mayfield Road across from Ivydale Road. Dean's barn bears a striking resemblance to the barn behind the W. B. Smith residence on Lee Road. (Courtesy of the Cleveland Heights Historical Center at Superior Schoolhouse.)

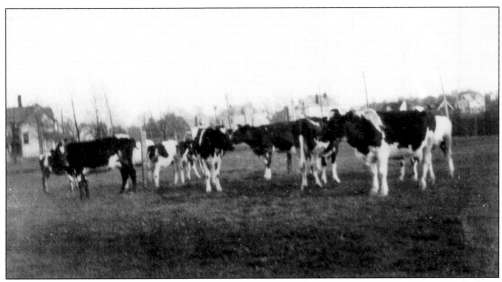

A dairy herd was kept at Forest Hill for many years. The estate's pasture was situated along Mayfield Road between Superior Avenue and Lee Road. Another pasture was located at the northwest corner of Mayfield and Taylor Roads. John D. Rockefeller bought those 35 acres from Charles and Julia Higgins in 1881. From 1925 to 1929, this was the site of the Cleveland Heights Fourth of July fireworks display. (Courtesy of the Rockefeller Archive Center.)

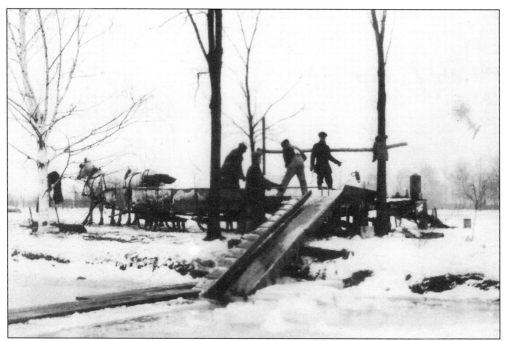

An important part of the estate's work in the winter was cutting ice from its two lakes. The ice would then be hauled to barns and stored in hay and sawdust, where it could last over a year. In February 1880, superintendent H. M. Sinclair reported to John D. Rockefeller in New York City that he had cut and stored 40 loads of ice. (Courtesy of the Rockefeller Archive Center.)

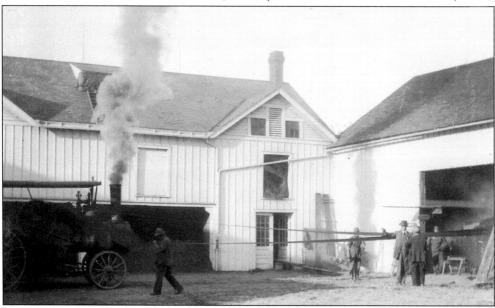

As John D. Rockefeller bought farmland adjoining his estate, he also acquired the farmhouses and barns. Often those buildings were moved to other locations. This undated photograph is labeled "Threshing Day." The location is not identified, but the powerful farm machine would have been used to separate the grain or seeds from crops such as hay, wheat, and corn, which were all grown in the estate's fields. (Courtesy of the Rockefeller Archive Center.)

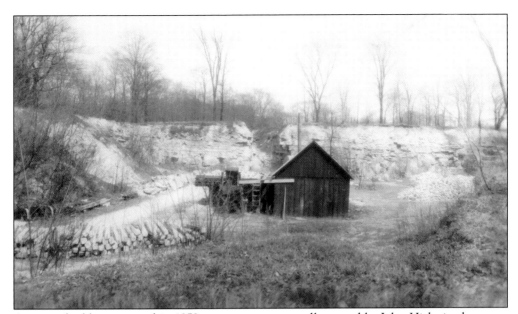

A quarry had been opened in 1850 on property eventually owned by John Hicks in the upper reaches of the Dugway Brook Valley near Superior Avenue. Hicks sold his extensive acreage, including the four-and-a-half-acre quarry site, to John D. Rockefeller in 1886. It is uncertain if this is the same quarry photographed in 1926 by Andrew Thomas. In 1931, the *Heights Press* reported that stone from Rockefeller's abandoned quarry was being used in the Forest Hill Development. (Courtesy of the Rockefeller Archive Center.)

This view looks across the floor of the Dugway Valley to the main carriage road bridge in 1926. The bridge was constructed from rough-hewn stone probably quarried on the property. The road along the valley floor leads to the upper reaches of the valley and to the vicinity of the 1850 quarry, which appears in the 1874 *Atlas of Cuyahoga County Ohio*. (Courtesy of the Rockefeller Archive Center.)

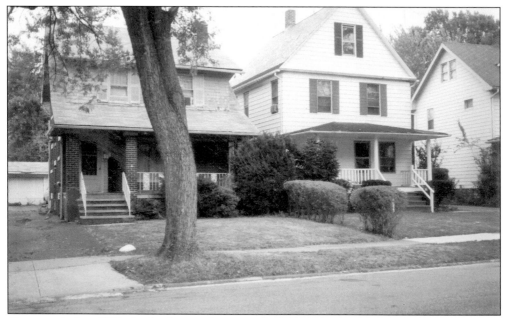

Photographed in 1996, the five homes shown on these two pages still stood in a row on the west side of Lee Road in the early 1920s, near the present intersection of Monticello Boulevard. The home on the left was at 1470 and the one on the right at 1474 Lee Road. They were part of the small homestead lots and farmhouses of the Phare family, although by 1925 they were not all owned or lived in by Phare descendants.

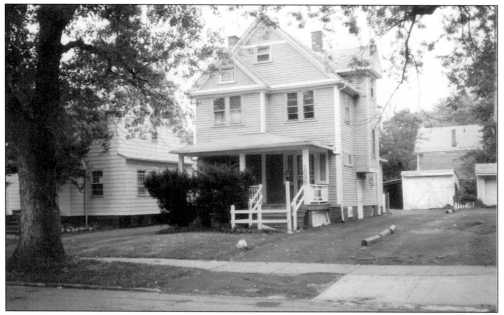

This house was located at 1476 Lee Road. Anticipating the widening, paving, and straightening of Lee Road in Cleveland Heights from Mayfield Road north to the city limits, John D. Rockefeller Jr. purchased properties along the street in 1925. The houses, bought by Benjamin Whittaker in 1928, were then moved across the open fields of the Forest Hill Development to Taylor Road by the Lowrey Brothers Company.

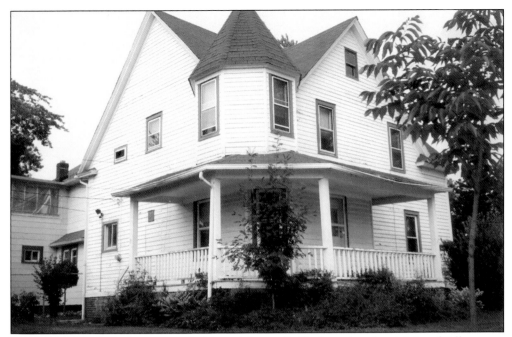

From Taylor Road, the homes traveled down Monticello Boulevard to the vicinity of Yellowstone Road and became part of the Rapid Transit Land Sales Company allotment. This Queen Anne was moved from 1480 Lee Road. By April 1929, the *Heights Press* was reporting that "grading of Lee Road in the Rockefeller property already has been started and the road will be ready for paving this spring."

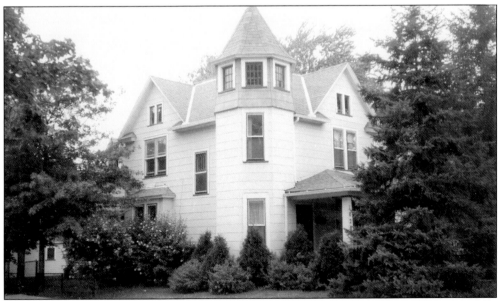

Thomas Phare bought his Lee Road property around 1865. His son William Phare owned a small general store on Mayfield Road near Superior Avenue, at the former site of the Cleveland Heights City Hall. He served as postmaster, the first clerk of the village of Cleveland Heights, and in 1912 was elected mayor. This home was located at 1518 Lee Road.

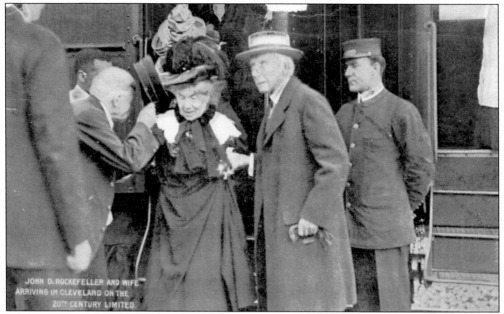

In 1884, John D. Rockefeller established legal residence in New York City when he purchased a townhouse at 4 West 54th Street near Fifth Avenue and not far from Central Park. By then, the family had been spending winters in New York, first at the Windsor Hotel and later at the Buckingham Hotel on Fifth Avenue across from St. Patrick's Cathedral. They arrived in Cleveland in late spring, spent the summer at Forest Hill, and departed for New York in the fall.

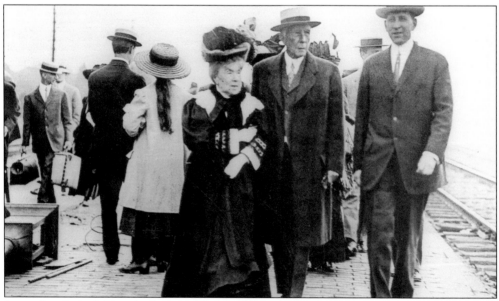

Long after their children had grown, Laura and John D. Rockefeller continued the yearly ritual. Rockefeller even spent the customary time at Forest Hill the two summers of 1916 and 1917 after his wife died. Reporters and photographers were invariably assigned to cover and photograph their arrival, which by 1912, when these photographs were taken, was at the Coit Road station in Bratenahl. (Courtesy of the Western Reserve Historical Society.)

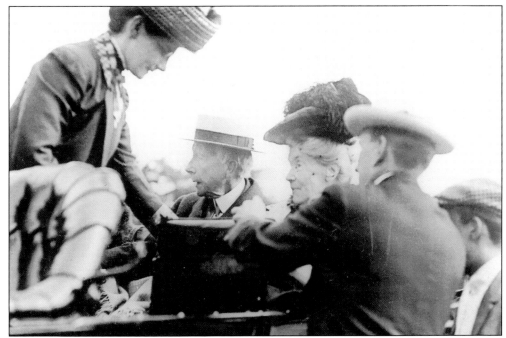

One photographer who regularly drew the assignment, and photographed the famous Clevelanders many times, was Andrew Kraffert of the *Cleveland Plain Dealer*. Kraffert's images of the train arrival were turned into popular postcards. Here the Rockefellers are being covered with a lap robe. From the Coit Road station near Lake Shore Boulevard and Eddy Road, they traveled by open car to the Euclid Avenue entrance of Forest Hill. (Courtesy of the Western Reserve Historical Society.)

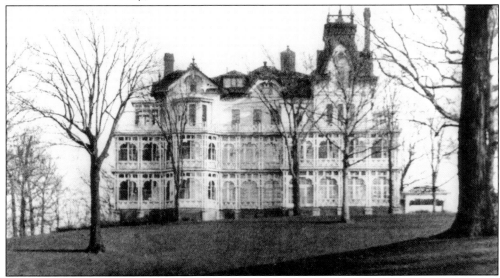

Taken slightly below the crest of the hill, this photograph is very rare because it shows the entire length of the front of Forest Hill—from where the land falls off toward the east ravine at the left of the house to the porte cochere on the right. The view not only illustrates the immense size of the mansion (with over 40 rooms), but imparts a sense of the loneliness when Forest Hill was closed in the winter months. (Courtesy of the Western Reserve Historical Society.)

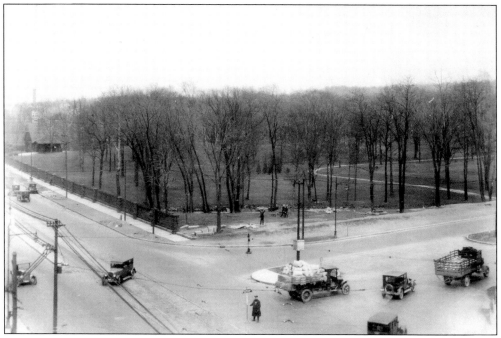

By 1926, when Andrew J. Thomas took this photograph, the intersection of Euclid and Superior Avenues was a heavily trafficked thoroughfare. Superior Avenue had been widened in 1924 to four lanes with a median strip to accommodate a possible transit system. In this image, sections of the estate's iron fence still lie on the ground. The gatehouse can be seen to the far left. (Courtesy of the Rockefeller Archive Center.)

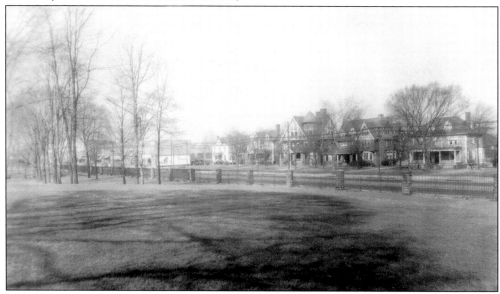

Across from the estate, seven large homes lined the north side of Euclid Avenue. The mansion at 13605 Euclid Avenue, fifth from the left, was the residence of Henry A. Taylor, a descendant of both the Doan and Taylor families. He was a friend of John D. Rockefeller and often visited Forest Hill. Active in civic affairs, he served as a trustee of the A. M. McGregor Home from 1906 and became its vice president in 1914. (Courtesy of the Rockefeller Archive Center.)

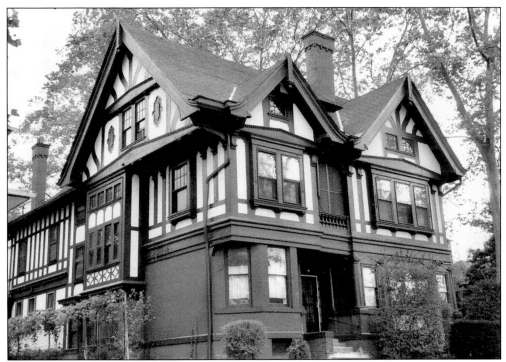

Mary Ann Rockefeller Rudd, John D. Rockefeller's sister, and her husband, William Cullen Rudd, built this Tudor Revival mansion on Euclid Avenue in East Cleveland in 1905. It was only a few blocks from the entrance to Forest Hill. The two-and-a-half-story brick and frame house incorporates a number of architectural features that make this style so appealing: wide timbering, thick bargeboards, gables and eaves, a steep roof, and bay windows.

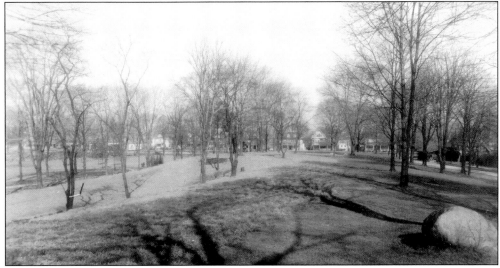

A knoll separated the Euclid Avenue entrance gates, gatehouse, and main carriage drive, seen on the far right of this 1926 photograph, from the Dugway Brook and Valley to the left. Of the seven homes in the block across from the estate, one still stands on the northwest corner of Euclid Avenue and Wheeler Street. It was situated directly across from the entrance gates to Forest Hill. (Courtesy of the Rockefeller Archive Center.)

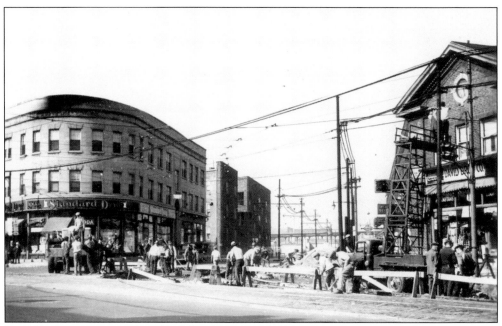

By 1938, the streetcar tracks at Euclid and Superior Avenues were once again under construction. These two photographs are dated October 22, 1938. The office building on the northwest corner of the intersection with a Standard Drug is probably where Andrew J. Thomas took his photograph in 1926. The tracks of the Nickel Plate Railroad can be seen in the distance. (Courtesy of the City of East Cleveland.)

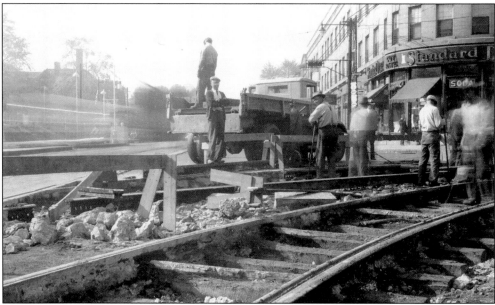

From Superior Avenue to Lake View Cemetery, Euclid Avenue is still lined with imposing homes and mansions. This image gives an idea of the size of the tracks and planks of the Superior Avenue streetcar line as it made a sweeping curve in front of the Rockefeller estate. Here it merged with the Euclid line of the Cleveland Electric Railway Company on its way to the Windermere car barns. (Courtesy of the City of East Cleveland.)

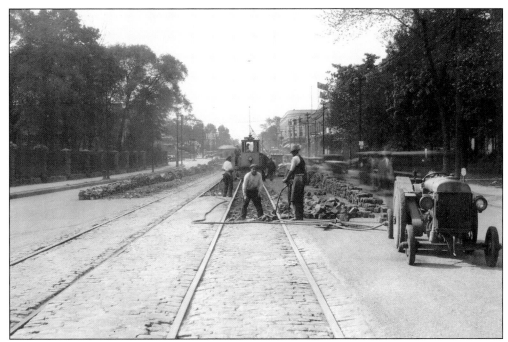

The estate's entrance gate pillars on Euclid Avenue were topped with enormous ornamental vases holding plants and trailing vines. The two pillars, seen on the far left, are also capped with flowers. This photograph is dated October 10, 1931, and labeled "Breaking up old pavement." Euclid Avenue was under constant change. In 1896, the landowners on each side of the avenue had relinquished 13 feet of their property as the entire length was widened through the village of East Cleveland. (Courtesy of East Cleveland Public Library.)

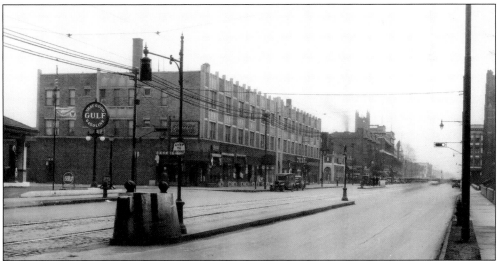

The developers of the Forest Hill allotment planned to connect Forest Hills Boulevard with Eddy Road. Excavation actually reached almost as far as Euclid Avenue when residents stopped it with an injunction in 1930. Visible in this 1931 photograph of Eddy Road and Euclid Avenue are the tower of Windermere Methodist Church (left), inspired by the tower of Magdalen College at Oxford University, and the Gothic tower of St. Philomena Parish School (right) at Vassar Road. (Courtesy of East Cleveland Public Library.)

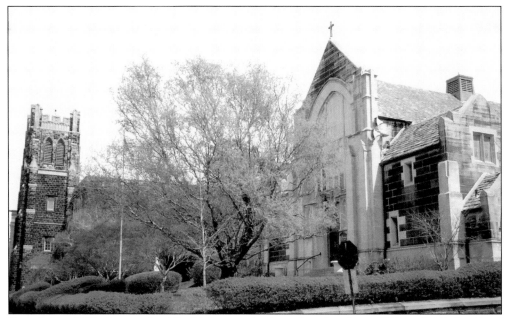

Founded in 1902, the parish of St. Philomena built its first church in 1903 on Wellesley Road in the English Gothic Revival style. In 1924, the church was remodeled and enlarged with its entrance facing Euclid Avenue. The parish complex, its church, rectory, and former parish school are bounded by Euclid Avenue, Vassar Road, Fernwood Avenue, and Wellesley Road and located in the Knight and Richardson allotment, which was surrounded by the Rockefeller estate well into the 1920s.

Vassar Road, used as a service entrance to the Rockefeller estate, led to the gardener's house and greenhouses. John D. Rockefeller regularly sent his gardeners and caretakers to the grounds of St. Philomena. In 1937, Msgr. Joseph Smith, then pastor of St. John's Cathedral and former pastor of St. Philomena, told the *Cleveland Plain Dealer* that "Rockefeller always was doing things for people's gardens and grounds" and "was a great one for moving trees."

In 2000, as part of the Greater Cleveland Regional Transit Authority Euclid Corridor Transportation Project, an Ohio Historic Inventory was conducted of all the structures along Euclid Avenue from Public Square into East Cleveland and to the Louis Stokes Rapid Station at Windermere. This survey found the St. Philomena complex to be a notable grouping of ecclesiastical structures and one of the few intact complexes between Public Square and Doan Avenue in East Cleveland.

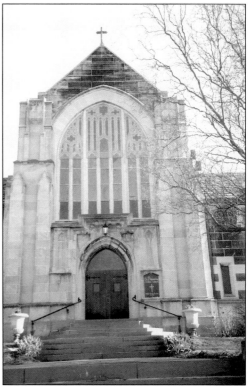

The tower of Windermere Methodist Church peers over the greenhouses. The estate at one time employed over 100 caretakers. In the summer, the employees would be augmented by college students, including young Canadian and future financier Cyrus Eaton. The greenhouses and gardens, located at the Vassar Road gate, supplied flowers for the Rockefeller burial plot at Lake View Cemetery and were delivered weekly by the estate's superintendent. (Courtesy of the Rockefeller Archive Center.)

Over the years, many children grew up in the homes and farmhouses on the perimeter of the estate or in some cases actually on the estate. One such lucky little boy was Cleveland Heights resident Ted Frost. His family rented the gardener's house at the Vassar Road gate from 1924 to 1927, when these photographs were taken. (Courtesy of Ted Frost.)

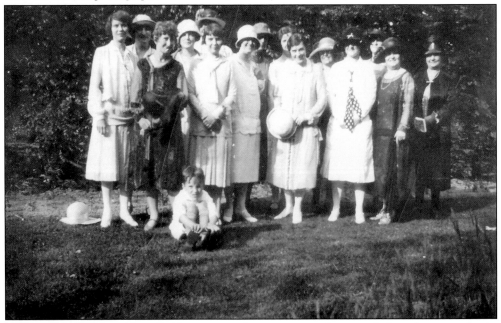

Ted's mother, Florence Frost (left), gave a garden party near the estate's formal rose garden in June 1926 for a visiting cousin from San Francisco. Ted sits on the ground in front of the stylish women, and understandably does not seem to be impressed with being able to entertain friends and relatives on the Rockefeller estate. (Courtesy of Ted Frost.)

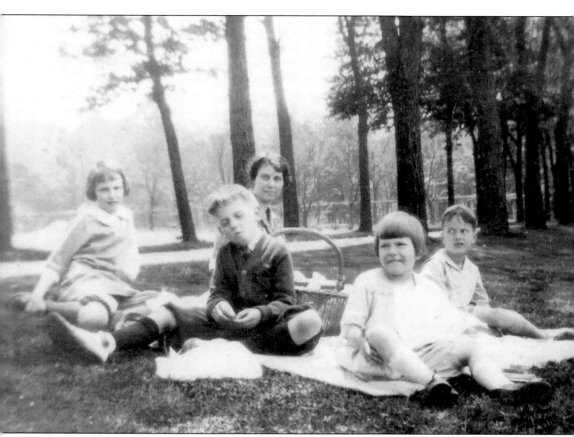

On a picnic blanket beside the gardener's house are, from left to right, Janet Frost, Richard Frost, Ted's mother Florence Frost, cousin Nancy Lyon, and Ted Frost. Ted remembers going to the lily pond, wading in the brook near the gatehouse, meeting gatekeeper Pat Lynch, attending Superior School, and coasting down "Camel's Neck Hill" in front of the site of the mansion in winter. Several years ago, his sister Janet recalled the orchard with apple, cherry, pear, peach, and plum trees, the goldfish in the lily pond, and that it took two men all morning to cut the grass around the gardener's house. This view looks south across the orchards and gardens to the grape arbor in the distance. On the other side of the arbor was the lily pond. In 1927, the Frosts moved to Cleveland Heights; the gardener's house at 1900 Vassar Road was made available to Gerald J. Otteson, a civil engineer on Andrew J. Thomas's staff, who moved his family from New York. (Courtesy of Ted Frost.)

In 1877, John D. Rockefeller sold 15 acres of his Forest Hill property to Peter F. McGuire. The land changed hands from 1880 to 1894, when it was purchased by Robert Blee, former Cleveland police commissioner and mayor of Cleveland from 1893 to 1895. McGuire subdivided it in 1905 into lots bounded by Belmore Road, Euclid Avenue, Windermere Street, and Terrace Road and, in 1904, sold two lots on Euclid Avenue to the Ursuline Academy of Cleveland. (Courtesy of East Cleveland Public Library.)

Located on Euclid Avenue between Marloes Avenue and Beersford Road, a block north of the Rockefeller estate, the East Cleveland City Hall is composed of two historic structures. The oldest, dating from the 1850s, housed East Cleveland Township's Union School. In 1906, the school became the East Cleveland Town Hall. A city hall, pictured here in 1955, was built in front of the town hall in 1916 in the Georgian Revival style, complete with a cupola, oculus windows, and a portico. (Courtesy of East Cleveland Public Library.)

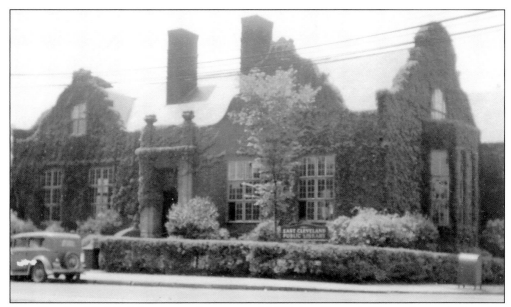

East Cleveland Public Library, seen here around 1930, is a Carnegie library. It was designed in the Dutch Renaissance style by the noted Cleveland firm Meade and Hamilton and completed in 1915. In 1916, John D. Rockefeller gave the library $3,600 for the purchase of additional land. In 1990, its magnificent barrel-vaulted interior was restored, and recently the library completed the addition of a stunning performing arts center. (Courtesy of East Cleveland Public Library.)

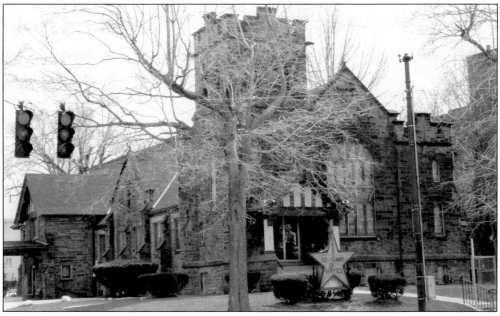

Starlight Baptist Church, formerly East Cleveland Baptist Church, was built at the corner of Rosemont Road and Euclid Avenue in 1903. The structure is rich in architectural detail with a half-timbered porch, battlemented tower, cornice featuring gargoyles, arch windows, buttresses, and massive stonework. John D. Rockefeller gave $11,000 to the building fund in 1902–1903, $1,000 toward the cost of an organ in 1905, and $2,000 toward the construction of the Sunday school in 1913.

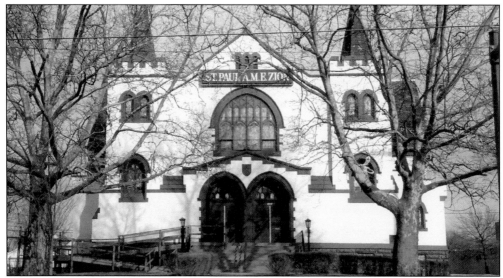

St. Paul African Methodist Episcopal Zion Church was originally the Willson Avenue Baptist Church. In 1882, John D. Rockefeller attended a lecture here by two teachers who were trying to establish a school to educate young African American women in Atlanta. Rockefeller was so moved by the story of Sophia Packard and Harriet Giles that he emptied his pockets and pledged more. The following day, the two women were brought to Forest Hill, marking the first of many visits for the founders of Spelman College and the beginning of the Rockefeller family's support of this famous school.

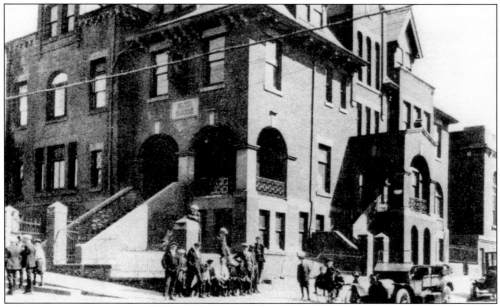

Alta House was founded in 1895 as a day nursery for working mothers in the Little Italy section of Cleveland. It soon expanded its mission and programs to encompass social settlement work. John D. Rockefeller had a close and ongoing interest in its work through his daughter Alta Rockefeller Prentiss, for whom the settlement, pictured here about 1920, was named. Rockefeller's gifts to Alta House totaled over $300,000. (Courtesy of the Western Reserve Historical Society.)

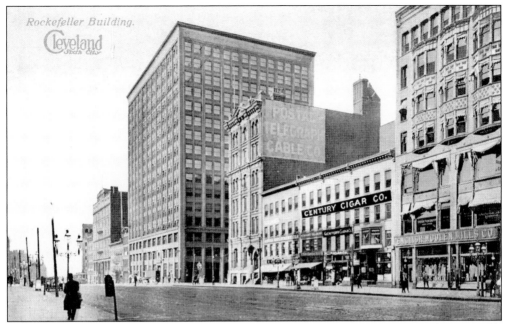

The Rockefeller Building, located at the corner of Superior Avenue and Bank Street (West Sixth), was an investment property financed by John D. Rockefeller. The 17-story brick structure, with its three lower stories of ornamental cast iron, is often compared to Louis Sullivan's Guaranty Building in Buffalo. Designed by the Cleveland firm of Knox and Elliott, it was built on the site of the Weddell House. When completed in 1905, it brought the design principles of the Chicago skyscraper to Cleveland.

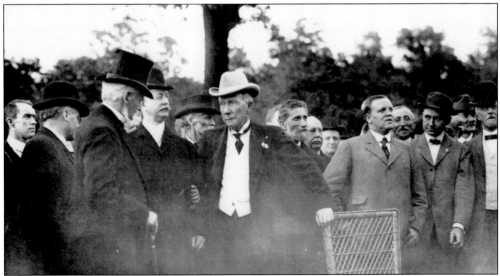

On September 26, 1905, over 400 businessmen and civic leaders called upon John D. Rockefeller at Forest Hill. The event was organized as a show of support for Rockefeller, who had been particularly beleaguered in the press with the publication of Ida Tarbell's book *The History of the Standard Oil Company*. After a reception and speeches, the group assembled on the lawn for photographs. The flag was flying over Forest Hill, for the day was the anniversary of Rockefeller's first employment in Cleveland. (Courtesy of the Western Reserve Historical Society.)

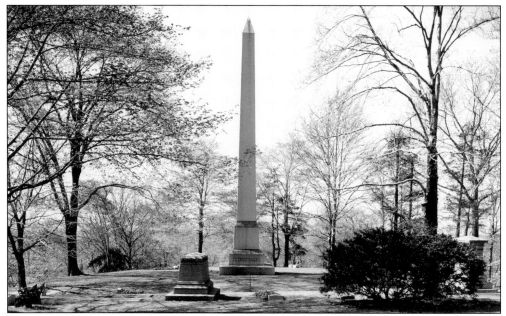

The Rockefeller burial plot, on a high knoll in Lake View Cemetery, looks out toward Lake Erie. The monument, pictured here in 1938, was made of a single piece of granite and is the largest obelisk and private memorial in the cemetery. John D. Rockefeller was interred beside his wife on May 27, 1937. The funeral cortege drove past Forest Hill, and the City of East Cleveland lowered its flags to half-staff. (Courtesy of the Lake View Cemetery Association.)

Lake View Cemetery opened in 1870. The Boston landscape architect and city planner E. W. Bowditch laid out its grounds in the manner of a rural, garden cemetery. As seen in this c. 1950 view of the approach to the Rockefeller monument, the cemetery has matured into a beautifully landscaped arboretum. John D. Rockefeller served on the board of trustees of Lake View Cemetery from 1878 to 1922. (Courtesy of the Lake View Cemetery Association.)

Two

THE FOREST HILL DEVELOPMENT
1923–1960

For years there had been speculation in the press as to what would become of Forest Hill. In 1923, John D. Rockefeller Jr. (1874–1960) purchased all of his father's real estate for $2.8 million and announced two years later, through the family's Abeyton Realty Corporation, a plan to build a model community on the farmland east of Lee Road. The development would serve as an example of the best in urban planning and design. Marketed to young professionals, this was not a philanthropic venture, but expected to be a profitable one. And it would not be hurried.

Rockefeller turned to New York architect Andrew J. Thomas (1875–1966). Thomas's longtime commitment to improving housing conditions in New York City (he is credited with the concept of the garden apartment and work on such Rockefeller projects as the Bayonne Housing Corporation in New Jersey, an apartment on York Avenue for employees of the Rockefeller Institute, and the Paul Lawrence Dunbar Apartments in Harlem) held him in good stead for a commission so closely associated with John D. Rockefeller Jr.'s boyhood. Thomas's collaboration with Clarence Stein at Radburn, New Jersey, left him firmly grounded in Garden City principles and the movement toward suburban development.

Thomas apparently asked for and received complete control over the project concerning its architecture, the layout of the streets, and the engineering of its infrastructure. He conceived a village of French Norman farmhouses. They would be clustered in blocks and, like his apartment buildings in New York, surround an interior courtyard of continuous shared green space. He planned the landscaping and such wonderful features as the wrought iron lanterns atop street lampposts, hand-hewn farmyard gates, and an open book in slate on some of the driveway pillars.

Once again, it would seem that fate had intervened. The stock market crash in 1929 and deepening depression brought the project to a standstill. While some housing construction continued—most notably five innovative "steel homes" built by the Arcy Corporation—it would be the post–World War II construction boom that would propel the completion of Forest Hill.

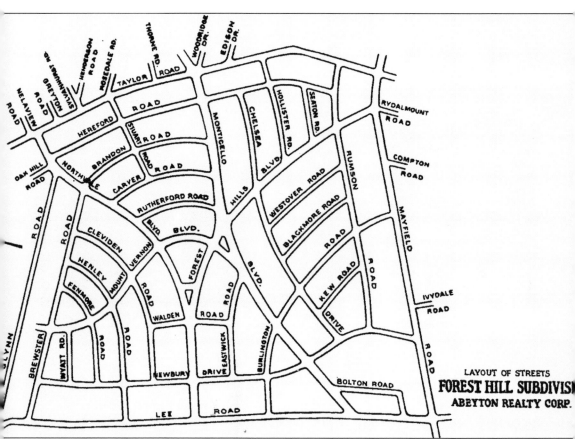

LAYOUT OF STREETS
FOREST HILL SUBDIVISI
ABEYTON REALTY CORP.

Andrew J. Thomas submitted the layout for the Forest Hill development to the Cities of East Cleveland and Cleveland Heights in August 1929. Brewster Road runs parallel to Glynn Road, but the rest of the streets were laid out in an intricate pattern of curvilinear roads and boulevards. Thomas's early work in Jackson Heights, Queens, New York, for the Queensboro Corporation was nearby Forest Hills Gardens. Planned by Governor Atterbury in 1910 for the Russell Sage Foundation, Forest Hills Gardens is an icon in the Garden City movement. This proximity, along with Thomas's work at Radburn, New Jersey, in 1928, gave him firsthand knowledge and experience in Garden City design principles.

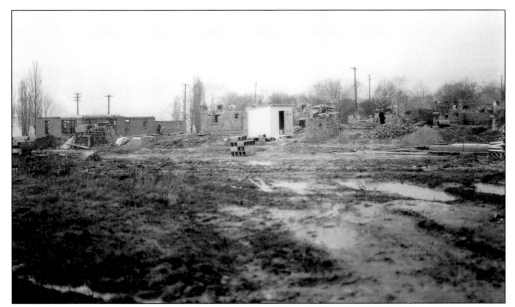

Construction on the homes did not begin until the end of 1929. By February 1930, the first floor of the Lee Road "Rockefeller," as these homes are affectionately called, had been finished. Having moved on to the next home on Brewster Road, the masons stand on scaffolding, working above the window level of the first floor. The utility poles and wires to the north are on Glynn Road. (Courtesy of East Cleveland Public Library.)

This eastward view was taken from a point 300 feet east of Lee Road. John D. Rockefeller acquired the acreage, part of the Lee family farm, in 1886. Brewster Road is a field of muddy trenches lined with piles of bricks, terra-cotta foundation blocks, and sewer pipes. The long construction shed and office are where Mount Vernon Boulevard now crosses Brewster Road. (Courtesy of East Cleveland Public Library.)

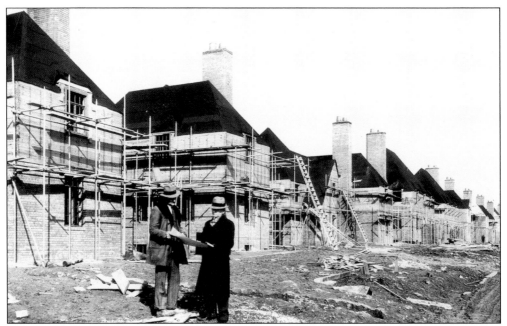

The two men, perhaps Andrew J. Thomas and his chief construction engineer, look at plans in front of the homes on Brewster Road. While the masonry work appears completed, the second-floor exteriors on many of these homes wait to be finished with either wavy-edged red cedar siding or hand-split shingles. The rafters and timbers of the attic have been covered with wood sheathing and heavy felt, but also await a slate or terra-cotta roof. (Courtesy of the Rockefeller Archive Center.)

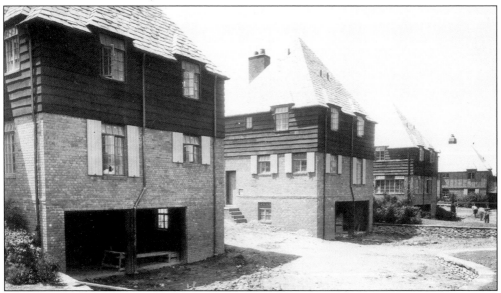

The basements of the homes were not excavated individually. Instead, long trenches were dug on each block. This allowed Andrew J. Thomas to place a two-car garage under the homes at basement level, a devise meant to keep cars out of sight, and also to provide a large expanse of driveway in order to maneuver in and out of the concealed garage. The landscaping has already been installed at the side of the homes. (Courtesy of the Rockefeller Archive Center.)

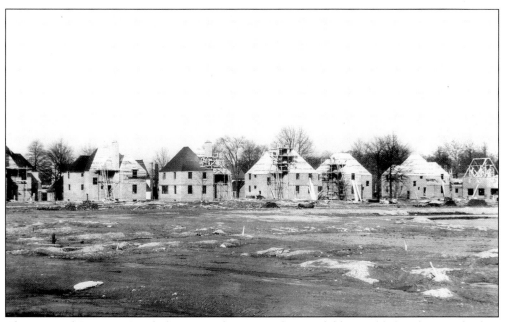

This view of Brewster Road, facing north across a barren field, was likely taken in the late winter or early spring of 1930. It shows the rapid progression of construction from a home almost finished on the left to the timbering of a roof at the far right. By September 1930, 15 of the 81 homes under construction had been completed and the project was formally announced to the public. (Courtesy of the Rockefeller Archive Center.)

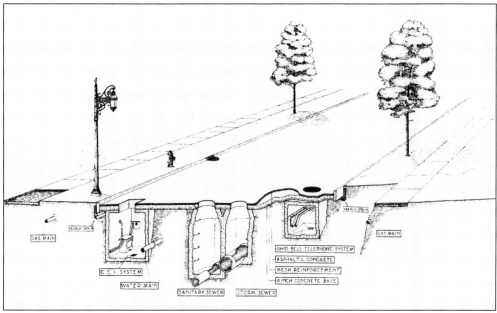

One of the outstanding features of the development—and certainly one of the earliest examples in town planning—is the absence of overhead wires and utility poles. This cutaway diagram, appearing in a *c.* 1931 sales book, shows the underground installation of the gas mains in the tree lawn, water main, separate sanitary and storm sewer lines, and the Ohio Bell telephone system. Large vaults under the streets hold huge transformers for the electric system.

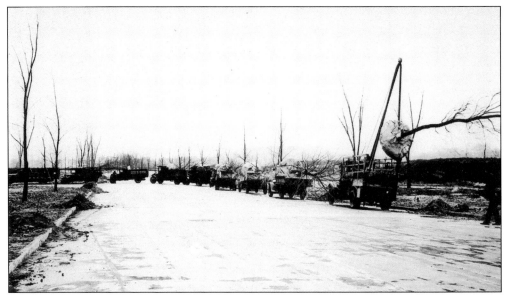

Cole Nursery of Painesville, Ohio, supplied the trees lining the streets of the subdivision. Today they tower and arch over the original 81 Rockefeller homes, creating a canopied vista on Brewster Road. The business's first location was on Mentor Avenue near the Lake County Fairgrounds. Established in 1881, Cole Nursery was one of the oldest family-owned nurseries in Lake County, which was known into the mid-1900s as "the Nursery Capital of the World." (Courtesy of the Rockefeller Archive Center.)

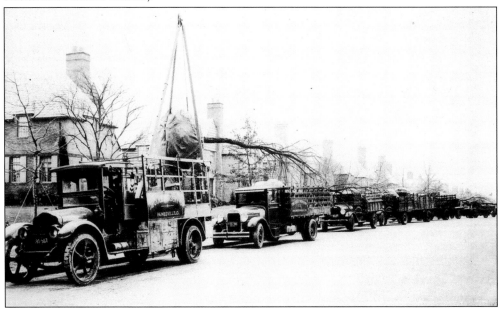

The two photographs on this page appeared in the Cole Nursery's 50th anniversary catalog in 1931. The caption read, "Cole's trucks moving 40 to 50 foot trees [average weight 7,000 pounds each] to the sensational Forest Hill Development on the old Rockefeller Estate in Cleveland. Over 500 mammoth truck loads of trees were delivered and planted here in only one month's time." The nursery established branches in Shaker Heights in 1930 and in Cleveland Heights in 1931. (Courtesy of the Rockefeller Archive Center.)

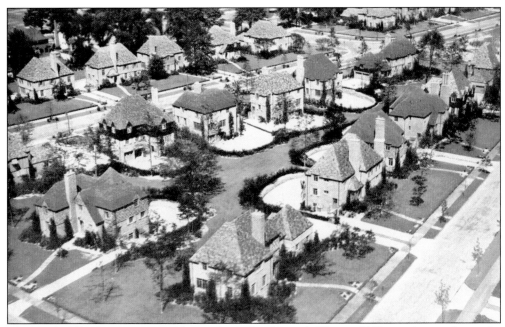

The Rockefeller homes were sold completely landscaped. This *c.* 1931 aerial view shows the corner of Wyatt Road and Newbury Drive and the lush foundation planting that surrounded the homes and backyard driveways. A thin line of privet hedge encloses the entire block. The curved front walk ends at the sidewalk with a triangle of Japanese azaleas, while the shared driveways have a narrow strip of grass along the property line. The interior courtyard or greensward of lawn, which was so integral to Thomas's concept of an open park-like common, unites all the backyards.

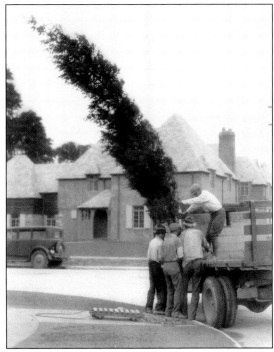

Cole Nursery offloads an enormous evergreen at the corner of Brewster Road and Mount Vernon Boulevard. Poplars, evergreens, hemlocks, cedars, and Hydrangea paniculata, in some cases almost two stories high, were placed at the corners and at the back wall of the homes. Maple, oak, and buckeye trees were planted in the lawns, seemingly at random. (Courtesy of Cleveland State University Special Collections.)

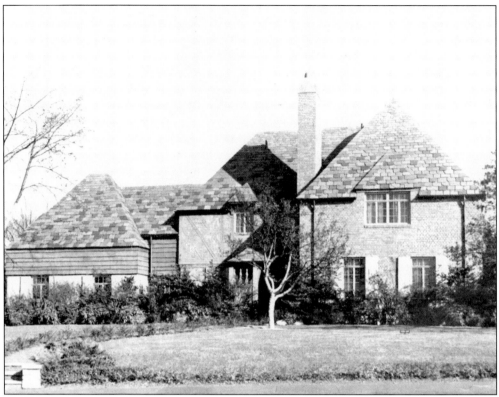

The corner Rockefeller at Brewster and Lee Roads was probably the most photographed of all the 81 homes throughout the 1930s. It was the first under construction in 1929 and was one of four that served as models. The home was furnished by an exclusive New York store in 1930. Seen here are the foundation plantings, curved walkway, and slate roof. The slates on the Rockefellers were graduated in size and thickness and varied in color.

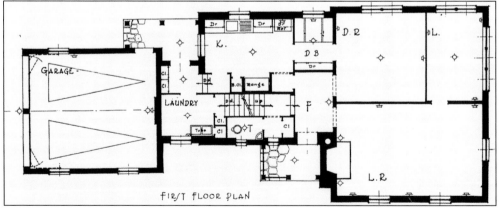

Andrew J. Thomas designed nine distinct house plans and labeled them by letter. There were two styles or floor plans for the corner homes, which were the largest in the development and the most expensive, originally selling for $40,000 to $43,500. This is Plan D, which also came with interior upgrades such as a tile floor in the dining room and a beamed ceiling in the front room. The corner Rockefellers were the only homes with attached garages.

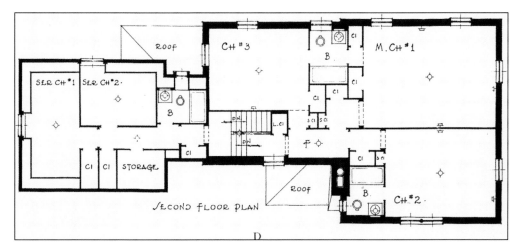

On the second floor of Plan D homes, there were five bedrooms and three bathrooms. Two of the bedrooms were placed over the garage, designated a servant's chamber, and made into a separate wing. Andrew J. Thomas designed three and a half bathrooms in every Rockefeller, an unheard of number for houses of this size. His goal was to make affordable a standard of living where "you don't have to be rich to live in a mansion."

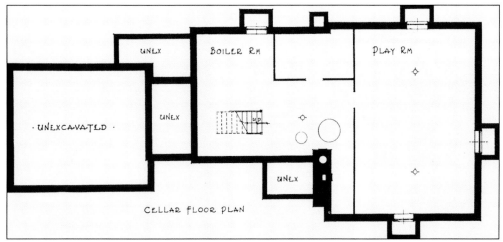

Without a garage at the basement level and with a laundry room on the first floor, the corner homes had a large living space in the basement that was designed as a playroom. Andrew J. Thomas did not have children, but he was enormously concerned about the well-being of children in New York City. The courtyards in his garden apartments had play areas, and inside there were rooms for baby carriages, music lessons, and play.

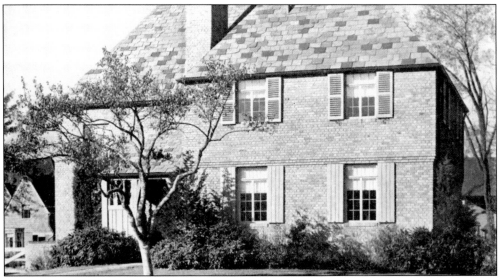

Plan K is typical of the majority of the 81 homes, which were built in mirrored pairs with a shared driveway separated by a pillar and gate at the top of the drive. The Forest Hill Development and the Marshall Field Garden Apartments in Chicago are the only known works of Andrew J. Thomas outside of the New York City area. Thomas did not believe in detached housing, and one could argue that these homes have more in common with his apartments than individual housing.

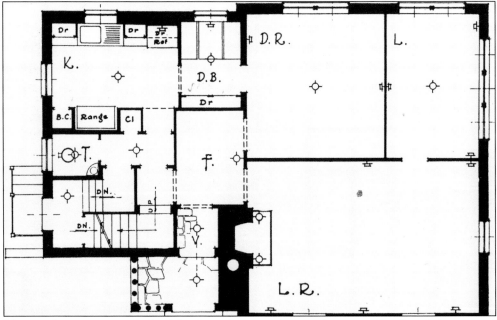

The porch is constructed of solid oak timbers, its slate roof supported with oak beams and hand-turned spindles and its steps and floor made of hand-split sandstone. All of the homes had a Pullman kitchen, separate pantry with a built-in breakfast nook, and a loggia on the first floor with two walls of windows, today used as a library or sunroom. Andrew J. Thomas introduced the loggia into his apartments for light and air, and gave every room an outside window, just as he did at Forest Hill.

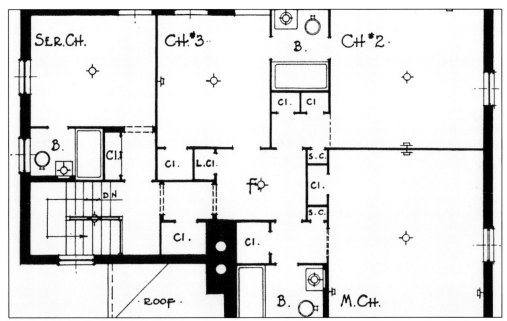

The attics under the steep pitched roof were meant only for storage. While they all had a finished floor, the attics were reached through a trapdoor either in the ceiling of the second floor hallway or a closet. Plan K homes were priced at $27,000. During the Depression, the original asking price for all of the Rockefellers was cut in half, and when they still did not sell, the Abeyton Realty Corporation leased the homes.

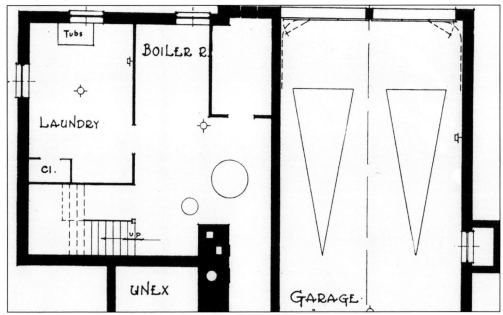

The garage in Plan K is concealed under the living room. The homes were designed to be practically fireproof with terra-cotta foundations, steel I-beam construction, four inches of reinforced concrete between the basement and first floor, and steel lath and plaster walls. The solid oak paneled garage doors were manufactured by the Kertscher Woodworking Company in Elmira, New York. They slide on a track to the inside of the garage.

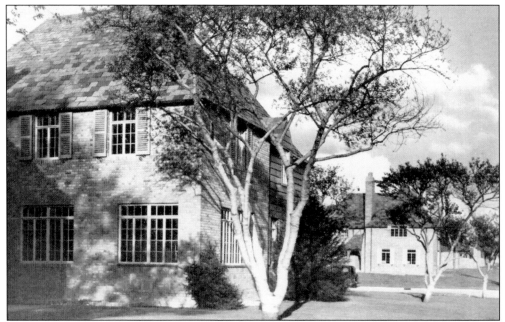

This image appeared in a handsome sales booklet with a vellum cover and envelope. The booklet was not dated but was reproduced as an eight-page article in *Bystander* magazine in October 1930. While the sales booklet provided a wealth of information on the history and construction of the development, the exquisite photographs really help document the landscape design.

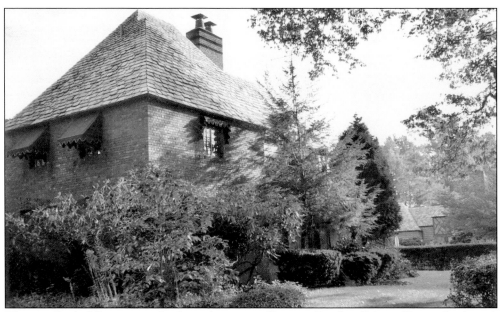

The same Rockefeller is pictured today at the corner of Brewster Road and Mount Vernon Boulevard. It has retained much of the original landscaping. The whole effect of the landscape design in 1930 was to convey a sense of permanence, a sense of harmony and cohesiveness. The goal was to create the illusion of an established community in the form of a French Norman village.

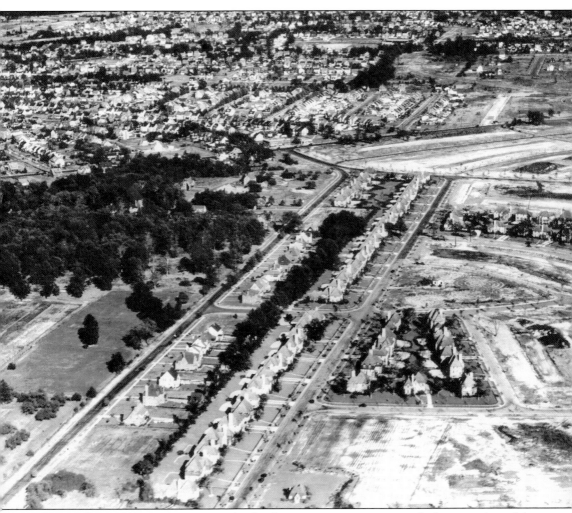

From 1931 to 1938, construction in the development came to a stop, with the exception of the five homes built by the Arcy Corporation in 1936 on Monticello Boulevard. This view by Aerial Surveys, though undated, was probably taken around 1931. It is looking east toward Taylor Road. The two parallel roads are Brewster and Glynn, both of which travel from Lee Road to Northvale Boulevard. The Rockefellers line the north side of Brewster Road, Northvale Boulevard, and the far end of Glynn Road. There are two completed blocks. One is bounded by Brewster Road, Mount Vernon Boulevard, Wyatt Road, and Newbury Drive and can be seen in the foreground. The other is bounded by Brewster Road, Cleviden Road, Mount Vernon Boulevard, and Henley Road. In the lower part of the photograph is the sales office at 2039 Lee Boulevard. The land is scarred with excavated trenches, which remained open to the great delight of neighborhood children, who rode their bikes up and down the dirt walls. (Courtesy of the Western Reserve Historical Society.)

Bricks were laid in common bond, as seen in this *c*. 2000 photograph, in an alternating pattern of a row of headers, the small end of the brick, and a row of stretchers, the narrow side of the brick. In November 1929, the *Heights Press* reported that the 600 homes would require 20 million bricks and that the contract, which went to the Goff-Kirby Company, comprised "the largest single brick contract ever awarded in the United States." (Courtesy of William B. Weisel.)

Andrew J. Thomas designed this semi-open book of slate and mortar after one he had seen on an approach to a European university. He placed the slate book on the driveway pillars of the corner Rockefellers. Thomas also capped all the driveway pillars with large pieces of slate and mortar. He used a similar treatment on the walls of the small side courtyards of the apartment he designed in 1926 on York Avenue in New York City, for employees of the Rockefeller Institute.

METROPOLITAN

Largest Maker of Paving Brick in the World

CANTON, OHIO

The Metropolitan Paving Brick Company of Canton, Ohio, supplied the bricks for the construction of the 81 Rockefeller homes and the Heights Rockefeller Building. The heavy sanded Yellowstone face brick, named Stapleton Blend, was specially produced and developed for the project by Andrew J. Thomas in a range of colors from light pink and tan to red. The bricks were kilned at Metropolitan's Bessemer plant in Bessemer, Pennsylvania. The Rockefeller homes have considerable architectural detail executed in brick. There is a course of brick at the first-floor level, and at the second-floor level the homes are all brick. Under the loggia windows, the bricks have been laid in a "basket on edge" pattern. The massive chimneys were constructed with varied and detailed brickwork.

an enchanting village

"*Once upon a time a young lad lived on a magnificent estate called Forest Hill. Acres upon acres of smooth, sunny lawns and majestic woodlands were his playground. On a high plateau to the East lay broad, rolling farmlands surrounded by wooded acres. To the North, Lake Erie glistened in the sun. The boy grew up and went to another part of the world . . . and with him went many golden memories.*"

And now . . . John D. Rockefeller, Jr. proposes to make his boyhood playground the playground of those who make their homes at the new Forest Hill. And such a playground!

Suppose you lived in one of the charming Forest Hill homes. Walk out of the front door in your golf togs and in five minutes you're ready to tee off on one of the most famous golf courses in the country. Or—don your riding clothes . . . miles and miles of beautiful winding roads and bridle paths await you. Or take the children to that marvelous "Play Spot" provided for their delight, just across the way.

And that's not all! Plans are fast going forward which will make Mr. Rockefeller's splendid visions of Cleveland's first year-round Country Club a reality. Tennis, squash and hand-ball courts, bowling alleys and, of course, a swimming pool . . . every facility for both indoor and outdoor recreation . . . made available on a most attractive basis to residents of Forest Hill.

Mr. Rockefeller's plans also call for the erection of a spacious Inn where Forest Hill residents will find everything needed for the royal entertainment of their friends.

Like the Sleeping Beauty's Palace . . . Forest Hill has come to life again, as an enchanting village where, under ideal conditions, Youth may live and play.

FOREST

That these promises of the future advantages of living at Forest Hill will be rapidly put into effect cannot be doubted when one sees the remarkable things already accomplished in the residential section. Here homes which are admittedly models of fine and practical construction have been erected. Ranging in price from $25,000 to $40,000, these homes, so building experts say, are many thousands of dollars under their market value.

The Abeyton Realty Corporation initiated an intensive advertising campaign in 1930. Advertisements appeared in Cleveland's metropolitan newspapers, local suburban papers, and in the Cleveland magazine the *Bystander*, which had merged with *Cleveland Town Topics* in 1929. This *Bystander* advertisement, published on November 22, 1930, promoted the prospect of living in "an enchanting village" on the Rockefeller estate. As further incentives to prospective homebuyers, it announced the development of a country club and inn and the use of Rockefeller's

where youth may live and play

golf course, which was "to be rebuilt by one of the foremost golf architects in the country." The interior photograph was taken in the front room of the corner Rockefeller at Lee and Brewster Roads. One of the model homes, it had been furnished in 1930 by W. and J. Sloane, a New York department store on Fifth Avenue known for its oriental rugs, upholstery, and decorating department. (Courtesy of William B. Weisel.)

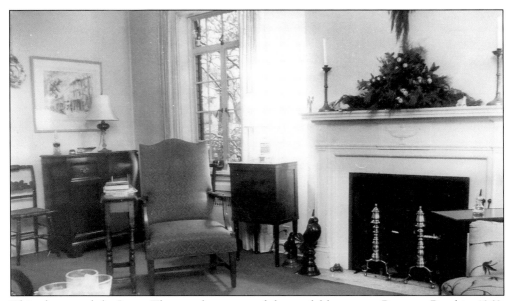

This photograph by James Thomas shows one of the model homes on Brewster Road in 1960. The mantels in the Rockefeller homes came from Jacobson's of New York and varied in motif. The metal casement windows were manufactured by Thorn of Philadelphia and the radiator covers by Hart and Hutchinson of New Briton, Connecticut. The far wall had a radio outlet and a concealed aerial wire leading to the antenna in the attic. (Courtesy of Cleveland State University Special Collections.)

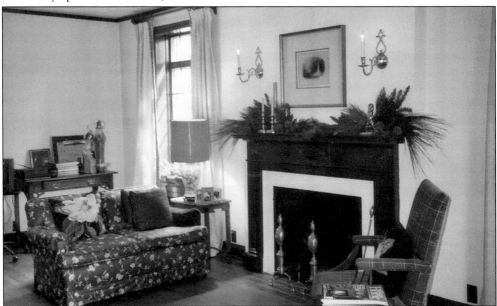

By 2006, the wall-to-wall carpeting, which in the 1950s was long strips sewn together, has been taken up, revealing the quarter-sawn oak flooring. The electric outlets above the mantle and the light switch have been uncovered. Apparently Andrew J. Thomas also designed the lighting fixtures for the homes, not pictured here. The original ones that have survived were crafted in metal and were described as "exquisite special things" by James G. Monnett in a November 1930 article in *Building Arts*.

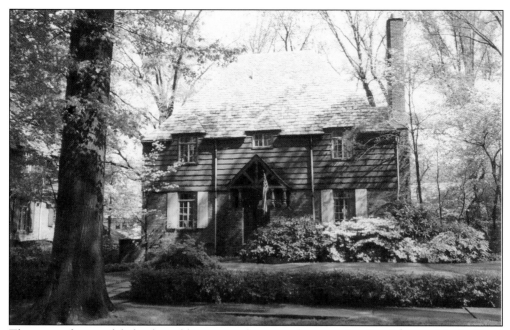

There were four models for the public to tour: the corner home on Lee Road; one on Henley Road furnished by and featured in the March 1932 *Ladies Home Journal*; and two on Brewster Road, one decorated by Nagele Studios and the other, pictured here, by Cleveland's Rorimer-Brooks Studio. This was the smallest of the Rockefeller homes and the only one designed with a center hall. A Plan J, it sold for $25,000.

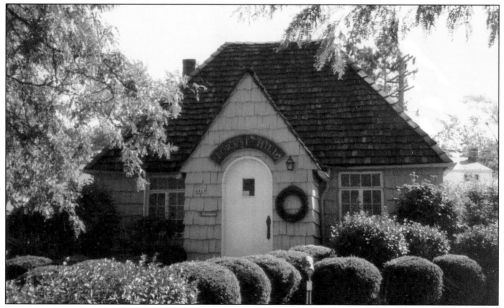

The Abeyton Realty Corporation's field sales office, a diminutive model of a Rockefeller, was located at 2039 Lee Road on the southeast corner of Brewster and Lee Roads. In 1937, it was moved to its present site at the southeast corner of Lee Road and Monticello Boulevard. From 1948 to the mid-1950s, it served as the sales office for George A. Roose's Forest Hill Development Company. In 1957, Roose sold the office to the Forest Hill Home Owners Association.

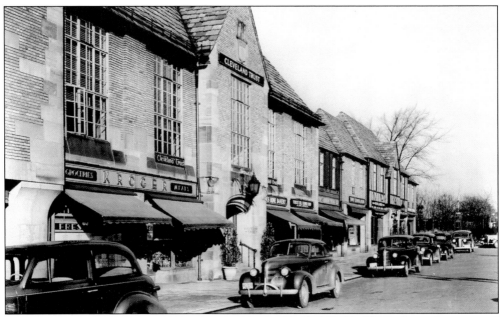

Completed in 1931 at a cost of $750,000, the Heights Rockefeller Building, shown here around 1938, was a crowded shopping center with a Kroger grocery store; Smada's Home Bakery; the Forest Hill Flower Shop, owned by John J. Spence; the Addison Tile Company; Temple Cleaners and Tailors; and Westfall and Koehler Interior Decorators. The Stamberger Company, at the far end, moved its hardware and plumbing store from Lee Road to the Heights Rockefeller Building in 1936. (Courtesy of the Western Reserve Historical Society.)

Looking north on Lee Road, this view shows the Rockefeller estate's pasture to the left, which was enclosed with a chain-link and cement-post fence in 1930 after the widening of Lee Road. To the right is the Heights Rockefeller Building. The ornamental lampposts, manufactured by the King Standard Company of Canton, Ohio, and lanterns were installed throughout the development and paid for by the Abeyton Realty Corporation. The lanterns were designed by Andrew J. Thomas and manufactured in New York City. (Courtesy of the Rockefeller Archive Center.)

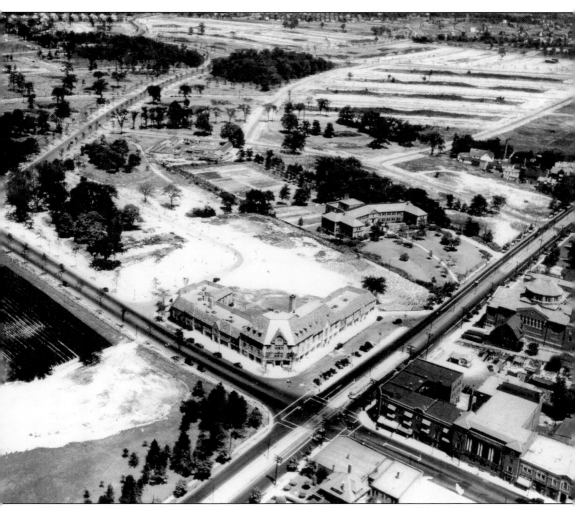

Taken at a low altitude on August 5, 1931, this aerial view of Mayfield and Lee Roads is a fascinating study of a landmark intersection. On the northeast corner, from left to right, is the Heights Rockefeller Building; to the east is the Montifiore Home, designed by Boston architect Charles Greco in 1917; and to the far right is the Dean Dairy. On the southeast corner, from left to right, is the 1915 Heights Masonic Building and the 1928 Heights Masonic Temple; to the east is the Temple on the Heights, also designed by Greco for the congregation of B'nai Jeshurun. The pasture across from the Heights Rockefeller Building has become one of the nurseries holding plant material for the Forest Hill Development. Visible in the upper left distance are the Rockefeller homes. Both the Heights Rockefeller Building and the 81 Rockefeller Homes were placed on the National Register of Historic Places in 1986. (Courtesy of the Western Reserve Historical Society.)

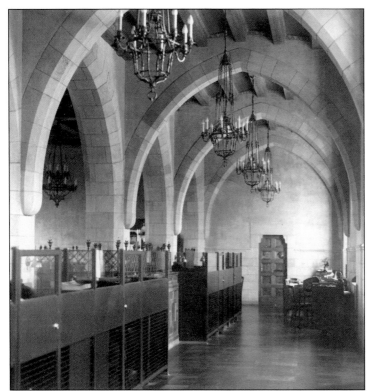

The east wing of the Heights Rockefeller Building, designed by Andrew J. Thomas, housed the Mayfield-Lee branch of the Cleveland Trust Bank. The description "a baronial banking hall" was almost an understatement for the second-floor bank. The seven teller stations were along the south wall below huge chandeliers and a beamed and vaulted ceiling. (Courtesy of the Cleveland Heights Historical Center at Superior Schoolhouse.)

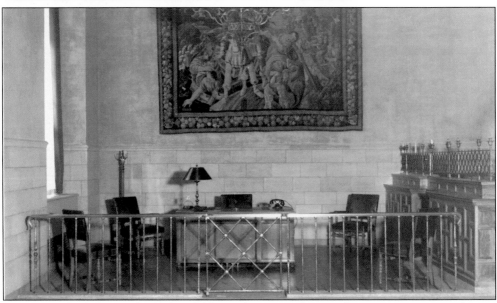

Patrons reached the 100-by-50-foot lobby with a stone floor and an enormous carved stone fireplace via a 10-foot-wide marble staircase from Mayfield Road. In the far corner, behind a brass rail and under a chandelier and tapestry, was the office of branch manager D. S. Winship. The Mayfield-Lee branch moved across the street from the Heights Masonic Building to its new location in the Heights Rockefeller Building in May 1931. (Courtesy of the Cleveland Heights Historical Center at Superior Schoolhouse.)

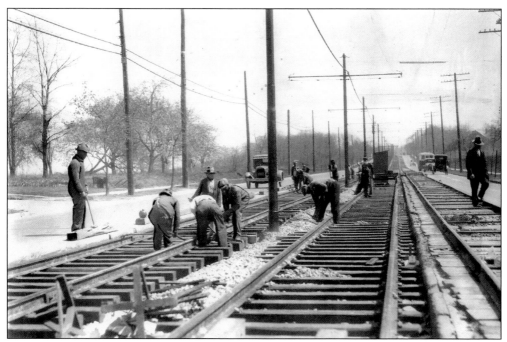

In the spring of 1929, the Cleveland Railway Company began to extend its line from Mayfield and Lee Roads to Warrensville Center Road. The *Heights Press* reported that it would take the steam shovels four weeks to excavate the road and lay the planks and 9,200 feet of double track. This view, dated April 24, 1929, looks east from Ivydale Road, showing the progress. The property acquired in 1925 for the Forest Hill Development appears on the left. (Courtesy of Cleveland State University Special Collections.)

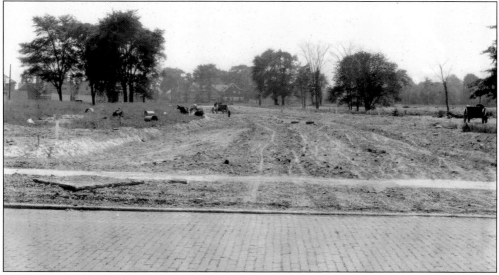

Manuel Halle purchased 17.5 acres of land in 1871 on the west side of Superior Avenue and, from 1897 to 1911, co-owned the property with John D. Rockefeller. Halle was an investor in real estate, a partner in the Schofield Oil Refinery, and with his brother Moses, a founder of Cleveland's Halle family. This photograph, dated July 22, 1926, shows construction of Luxor Road. (Courtesy of East Cleveland Public Library.)

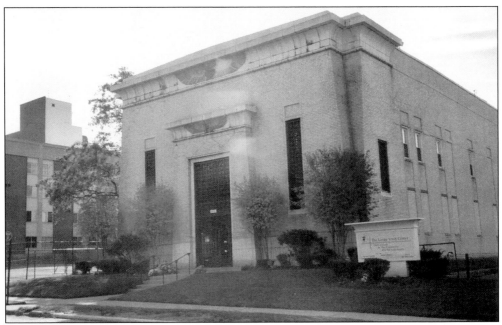

Between 1924 and 1928, three parcels of property on the edge of the estate were either donated or sold by John D. Rockefeller Jr. The Living Truth Center, formerly the East Cleveland Masonic Temple, was built on the Belmore Road land. This Egyptian Revival structure was designed by H. M. Morse and dedicated in 1928. The style, gaining popularity in the 1920s with the discovery of King Tut's tomb, is also related to the art deco movement.

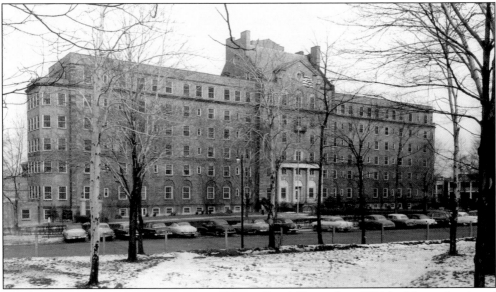

The land donated for the construction of Huron Road Hospital in 1924 had been the site of the estate's orchards and gardens. Founded as the Cleveland Homeopathic Hospital in 1856, it was located for many years in downtown Cleveland. After a long building fund campaign, construction began in 1931 on the seven-story brick hospital designed by the George S. Rider Company. Today Huron Hospital is part of the Cleveland Clinic Health System. (Courtesy of East Cleveland Public Library.)

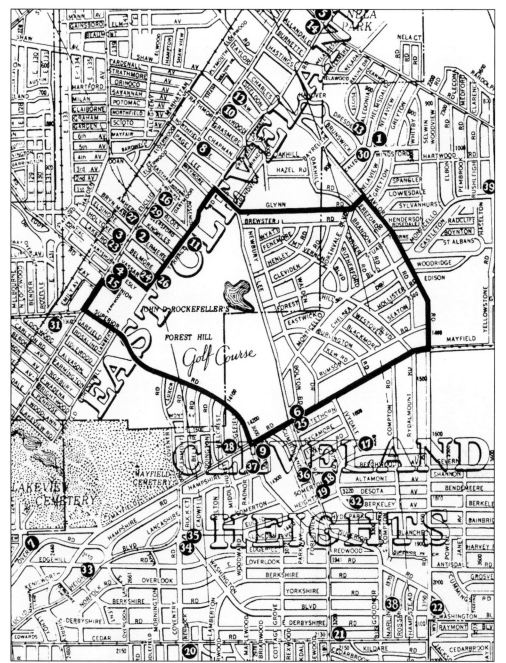

This *c.* 1931 map is from a large, three-ring binder sales booklet. Many of these booklets were handed down from one Rockefeller homeowner to another. The map promotes the location of the Forest Hill Development and its proximity to schools, churches, libraries, and the "New Huron Rd. Hospital," designated No. 26. The focus of the map, however, seems to be "John D. Rockefeller's Forest Hill Golf Course," which was enlarged and redesigned by Donald Ross in 1931 as an amenity, along with the addition of tennis courts, for the residents of Forest Hill. In April 1932, the *Heights Press* noted, "The golf course and tennis courts are to be used only by those who have purchased homes in the allotment."

In 1928, the East Cleveland School Board purchased 11 acres of the estate fronting on Terrace Road and engaged the architectural firm of Warner, McCornack, and Mitchell to design Kirk Junior High School. Built in 1930, the Georgian Revival school was said to have been modeled after Independence Hall. From 1999 to 2001, a community-wide effort worked to save the historic school from being torn down and replaced. The school was demolished in 2002. (Courtesy of Steven Morchak.)

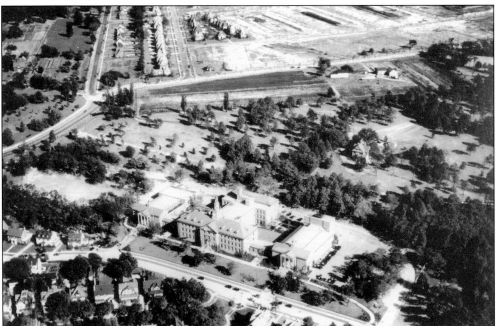

Taken about 1931 by Aerial Surveys, this view looks east from the junction of Terrace Road, Rosemont Road, Marloes Avenue, and Beersford Road. Before the extension of Terrace Road in 1917, the Rockefeller estate actually occupied a two-acre triangular-shaped parcel of land where these roads come together. Laura Lee's 10-acre farm and the Forest Hill Development can be seen on Lee Road. (Courtesy of the Western Reserve Historical Society.)

ARCY STEEL FRAME HOUSES

The newest conception

in Residential Building

THE ARCY CORPORATION • NEW YORK • CLEVELAND

In 1936, the Arcy Corporation of New York built five "steel homes" in Forest Hill for the Abeyton Realty Corporation. They are located on the south side of Monticello Boulevard between Burlington Road and Newbury Drive in Cleveland Heights. The prefabricated structural steel framework was made in sections and welded together on site. The interior walls were finished with Arcy metal lath and plaster. The homes were designed to withstand wind, fire, lightning, and termites; they were promoted as some of the most scientifically built residences in the country. (Courtesy of the Forest Hill Historic Preservation Society.)

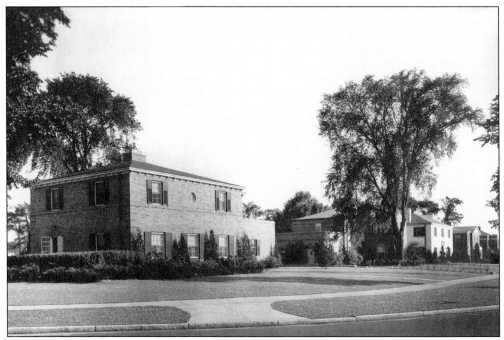

While Arcy interiors were heralded as the way of the future, the exteriors could be constructed in the Georgian, regency, classic, or Colonial styles. In December 1936, more than 3,000 people, who had to first obtain admission passes, visited the model home furnished by the Halle Brothers Company. It would not have gone unnoticed that the promotional brochure featured an Arcy Home under construction for Laurence Rockefeller in Pocantico Hills, New York.

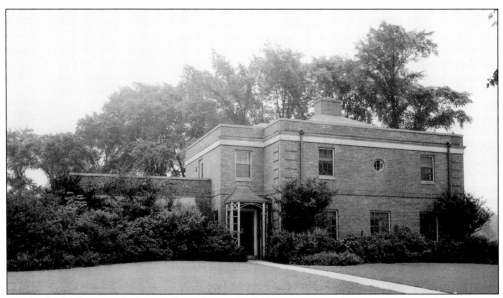

Inside, the built-in wardrobes, walk-in closets, bath-dressing room, lounge room, sun deck, terrace, kitchen snack bar, and air-conditioning system presaged the lifestyle of the 1950s. Indeed, the Ferro Enamel Corporation with the American Rolling Mill had built two prefabricated steel houses at the Chicago World's Fair in 1933 and one in 1936 at the Great Lakes Exposition in Cleveland.

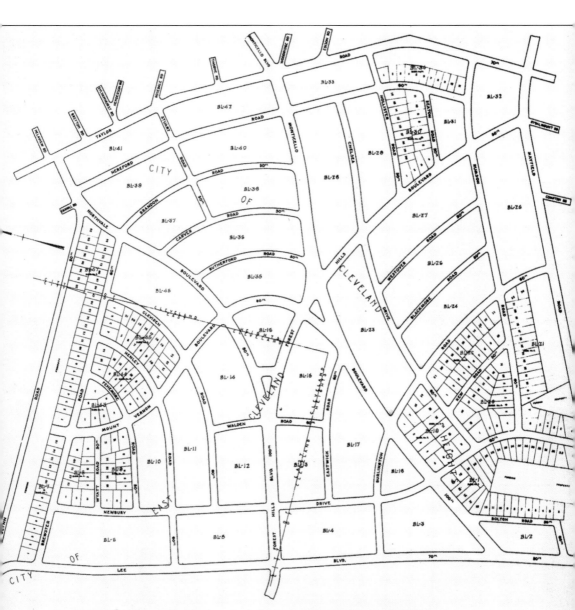

FOREST HILL HOME DEVELOPMENT

EAST CLEVELAND & CLEVELAND HEIGHTS

In the spring of 1937, the Abeyton Realty Corporation put 200 lots on the market, and by July the *Cleveland Plain Dealer* announced the beginning of a new building program in the southern part of the development. The Gunderson-Shepherd Company, with offices on Shaker Square, had purchased two lots from Abeyton on Kew Road with an option on 18 more. This *c.* 1940 map shows the allotted area of Forest Hill bounded by Chelsea Drive, Hereford Road, Rumson Road, and Newbury Drive. Prior to World War II, this location was developed with lovely Colonial-style homes designed and built by some of Cleveland's best-known architects and builders.

» «

sitive to definite modern trends in architecture its large wide

rmit the better new designs and the modern adaptation of

ional architecture, as well as the more typical traditional

. Careful community planning provides for attractive small

ll as more spacious homes.

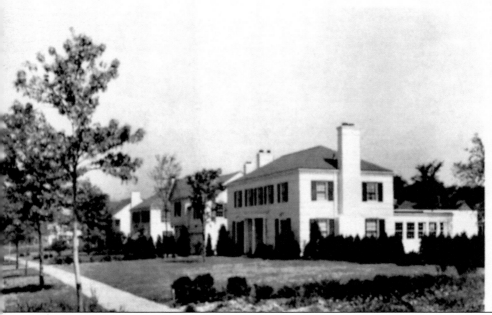

The c. 1940 sales booklet that promoted the pre-war homes was mindful of the lessons of the development's early years and was quick to point out that Forest Hill was now "sensitive to definite modern trends in architecture." The change in architectural style, the new look in promotional material, the homes with modern conveniences like air-conditioning and electric

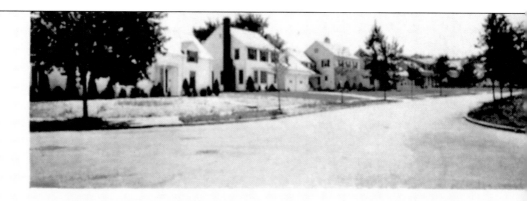

Looking South . . . on Hereford Road

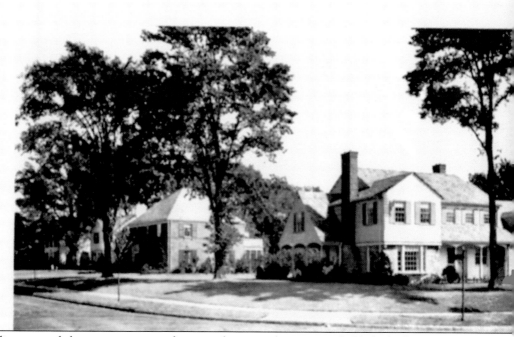

appliances, and the two-car garages facing and near to the street probably had a lot to do with the growing influence of the third generation of the Rockefeller family on Forest Hill. By 1937, both Nelson and Laurence Rockefeller were part of the decision making, as they sat on the Committee on Forest Hill Development.

This Burlington Road home is a stately Colonial built by Robert F. Gaiser in 1938. It was designed by Charles H. Hinman, who specified on the blueprint that the stone exterior should be painted white and the roof should be either slate or wood shingles. The home's central block and two wings are distinguished by a lunette window in the attic, dentil molding under the eaves, and a wide cornice at the roofline.

This Colonial on Burlington Road, also built by Robert F. Gaiser in 1938 and designed by Charles H. Hinman, was constructed in stone and brick. It includes such details as a wide dentil cornice at both the front and back of the house, a small window to the side of the front door with grille work, and a wrought iron lantern and porch railings. The standout architectural feature has to be the two bay windows with a copper roof and dentil cornice.

Eric Gaiser built this charming wood frame and stone Colonial on Blackmore Road in 1939. Architect L. H. W. Meyer incorporated a wealth of architectural detail into this home, including lap siding, a slate roof, rough-sawn spindles on the porch, and a Palladian window on the second floor. The architect labeled the garage on the blueprint the "motor room" and placed the house behind a white picket fence.

The Gunderson-Shepherd Company built this handsome brick Georgian on Kew Road in 1938. Architect R. Franklin Outcalt designed the center hall with a slate roof, a metal roof over the bay windows that flank the recessed front entrance, two fireplaces, and an out-swinging casement window above the front door.

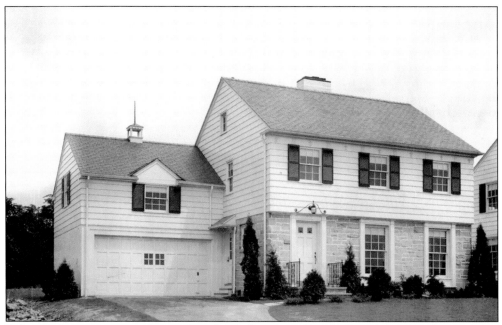

Robert F. Gaiser constructed several smaller Colonials on Hereford Road that were big in charm and detail. These two homes, both designed by Charles H. Hinman and built in 1938, stand side by side, and their floor plans mirror each other. This home has seven fleurs-de-lis across the cornice, a detail repeated in the corners of the frame around the door. The two front windows are framed in faux-wood columns, as is the front door.

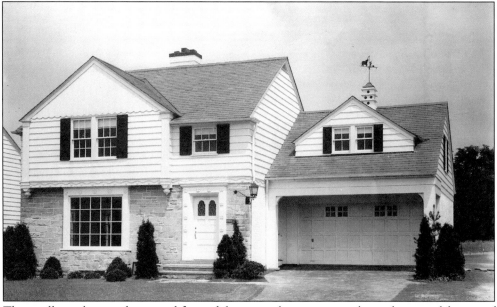

The small cupola over the second floor of the garage became a popular and repeated feature of the newer homes in Forest Hill. This one, sporting a weathervane, doubles as a birdhouse. Wood pendants hang from faux-wood columns on the second floor. A scalloped cornice with wood rosettes delineates the first and second floors. The rosettes are repeated across the top of the bay window and around the frame of the front door.

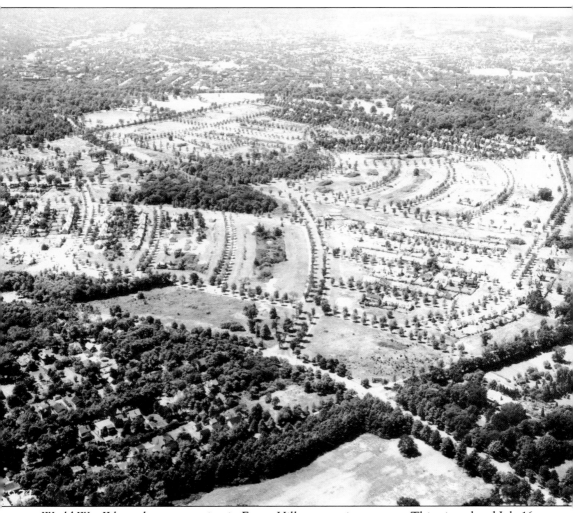

World War II brought construction in Forest Hill once again to a stop. This view, dated July 16, 1946, and taken by Aerial Surveys, looks northwest from Mayfield and Taylor Roads. While the roads are laid out and the trees lining those roads have matured some 16 years, the subdivision is still for the most part undeveloped. All of this was about to change. In 1948, George A. Roose, a businessman from Toledo, Ohio, together with a syndicate of partners, purchased the undeveloped property from the Abeyton Realty Corporation. Within seven years, Roose had sold most of the remaining lots to builders, who completed Forest Hill. The corner of Mayfield and Taylor Roads in the foreground was the site of Cleveland Heights's Fourth of July fireworks celebration from 1925 to 1929. The land, which gently descends toward Monticello Boulevard, was compared to a natural amphitheater accommodating, as the *Heights Press* noted in June 1925, not only "the thousands who will witness the display but the tourists who always flock in from neighboring communities." (Courtesy of the Western Reserve Historical Society.)

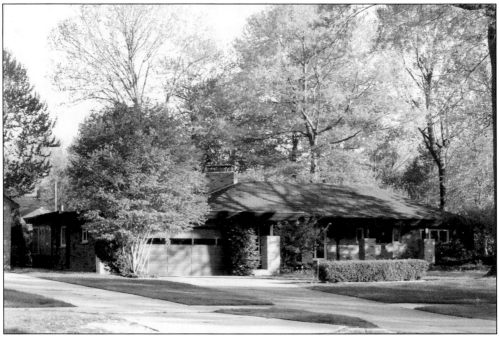

Cleveland architect Albert J. Sgro designed three homes in Forest Hill. Sgro's admiration and study of Frank Lloyd Wright are evident, as many of Wright's design principles come into play: low horizontal lines, hip roofs, and natural materials. This one was built on Monticello Boulevard in 1954. Sgro's use of brick, redwood, and stone, coupled with diagonal siting and small courtyard gardens, is his signature in these one-of-a-kind luxury homes.

The Keyes-Treuhaft Company built this home in 1938 on Chelsea Drive as a model equipped by the General Electric Company with an array of electric appliances and conveniences including air-conditioning. The home was designed by Charles H. Hinman and decorated by the Rorimer-Brooks Studios, while its landscaped grounds by Maurice Cornell were lighted at night. Described as a modified Pennsylvania Dutch Colonial, the trendsetting residence in its beautiful setting was open for view and not immediately put on the market.

Since 1951, the steeple of this lovely Georgian Colonial Revival church at Lee Road and Monticello Boulevard has been a Forest Hill landmark. The congregation of Forest Hill Church Presbyterian, however, has worshipped at three locations in Cleveland Heights for over 100 years. The congregation formed in 1903 and met in a home on Radnor Road, which they called Church House. In 1906, members moved to the Superior Schoolhouse and, in 1908, purchased a lot from Emil Preyer and built a church at the corner of Preyer and Mayfield Roads, across from the Rockefeller estate. In 1946, the congregation bought a triangular-shaped lot in the Forest Hill Development from the Abeyton Realty Corporation. The lot had been created with the extension of Monticello Boulevard to Lee Boulevard. Forest Hill Church Presbyterian was dedicated on May 20, 1951.

The California contemporary ranch homes of Toledo builder Donald J. Scholz constructed in Forest Hill in 1954 created enormous interest and captured the attention of Cleveland. Inspired by the architects of the Modernist movement and the deluxe ranch homes of California designer Cliff May, Scholz's homes are characterized by low, sleek, horizontal lines, often in an L-shaped arrangement with a two-car attached garage and a winged roofline with eaves overhanging the entry area, driveway, and patio.

Inside this Lee Boulevard California contemporary ranch, the light-filled floor plan, cathedral ceilings, exposed beams and rafters, and sliding glass doors blur the dimension between indoor and outdoor. The use of exterior building materials of wood, brick, and stone together with wood shake roofs, integrates these homes into the wooded park-like setting envisioned almost 30 years earlier by Andrew J. Thomas.

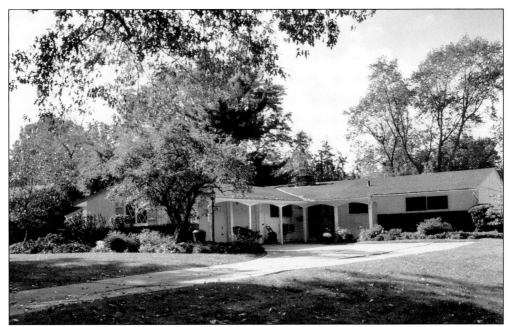

One of Donald J. Scholz's homes was a design he named Forest Hill. Like all of his California contemporary ranch homes, this Forest Hill model on Newbury Drive came with an array of options and additions including carpeting, drapery, a paint package, and wallpaper. Scholz helped pioneer the extensive use of prefabrication, which lowered the cost of production. His manufacturing plants were eventually spread across the country and delivered the component walls and parts to be assembled on site.

These residences were marketed as "America's most exciting homes." Indeed, Cleveland had not seen anything quite like these styles, which evoked a Californian and western lifestyle and incorporated the modernistic design and technological advances of the 1950s. In 1999, *Builder* magazine named Donald J. Scholz one of the 100 most influential people in home building in the 20th century.

Often when all structural landmarks have disappeared, the landscape still gives a clue of the built environment. This beautiful stand of ornamental crabapple trees is on the west side of Lee Road, across from Forest Hill Church Presbyterian. They are the same trees that were planted at the driveways of the Rockefeller homes in 1930 and are probably a remnant of one of the nurseries that held planting material in this vicinity.

At the intersection of Monticello and Lee Boulevards are many buckeye trees. This enormous buckeye tree stands next to the west wing of Forest Hill Church Presbyterian. The trees were known to be in the vicinity of the office of the superintendent of the Forest Hill estate at 1549 Lee Road, one block south of the church.

Three

FOREST HILL PARK
1938–1960

By the end of the 1930s, it was becoming apparent that the Rockefeller era in Cleveland was drawing to a close. On November 17, 1939, the *Heights Press* disclosed the impending sale of the Heights Rockefeller Building and correctly predicted that such a sale was the start of a "gradual withdrawal of Rockefeller real estate interests from that area." Unknown to the public, John D. Rockefeller Jr. had already authorized the sale of all of his Cleveland property. By then, however, a continuing and lasting legacy was taking form and shape on the grounds of the Forest Hill estate—the construction of a large urban public park. Rockefeller had fulfilled the wish of his father and clearly followed his own desire to preserve the natural beauty of his boyhood home. On April 14, 1938, he gave the greater part of the estate, 266 acres in all, to the Cities of East Cleveland and Cleveland Heights as an inter-city public park to serve the people of those communities and the population of Metropolitan Cleveland.

The selection of Cleveland landscape architect Albert Davis Taylor (1883–1951) was confirmed in late July 1937. It would be, however, Taylor's early training and apprenticeship under Warren Manning that he brought to the design of this Rockefeller gift that would elevate Forest Hill Park and give it a lineage to New York's Central Park. Taylor had absorbed the design principles and ideals of Frederick Law Olmsted. Such Olmstedian features as the Great Meadow, a large pastoral lake, axial vistas, and woodland walks known as "the Ramble" in Central Park, Taylor either incorporated into the development plan or preserved from the Rockefeller estate.

From 1938 to 1941, a corps of Works Progress Administration (WPA) workers labored to convert the estate to public parkland. By 1942, with a reported $2 million already spent, much of Taylor's plan had been completed, and the workforce, which at one time numbered 750 men, had dwindled to a few as America entered World War II. Today substantial portions of A. D. Taylor's plan remain intact. And within Forest Hill Park, if one looks carefully, the Rockefeller estate can still be found.

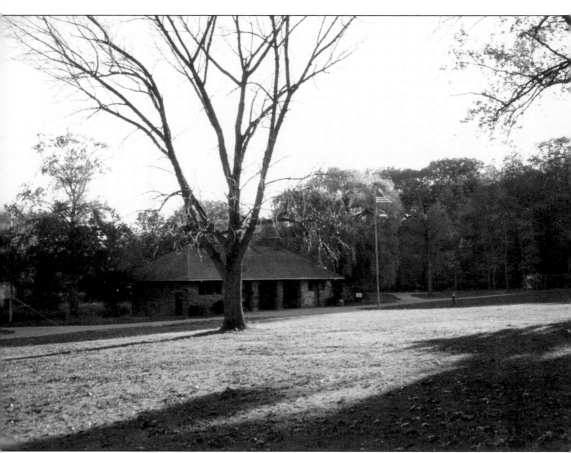

The boathouse in Forest Hill Park, designed by A. D. Taylor and constructed by the WPA, was completed in 1940. Facing southwest, toward the small stone footbridge that crosses the lake's outlet and spillway, the boathouse is nestled into the edge of the lake and integrated into the park's terrain. The Rockefeller's boathouse was located directly opposite on the other side of the water.

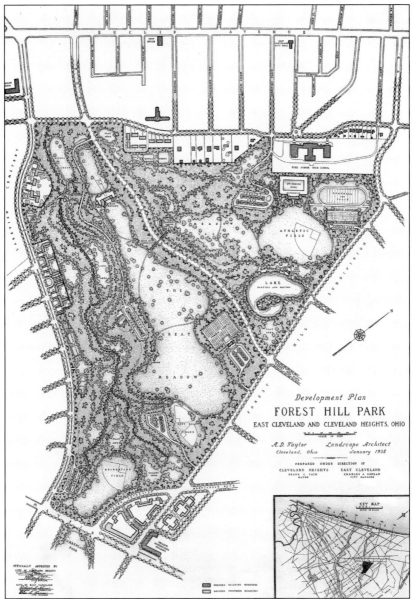

A. D. Taylor submitted his development plan for Forest Hill Park to the cities of Cleveland Heights and East Cleveland in January 1938. It was later printed as a bound volume in a limited edition as *Forest Hill Park: A Report on the Proposed Landscape Development*. The report was illustrated with photographs, maps, drawings, and aerial views. His office also produced a large number of blueprints, planting plans, and topographic maps submitted as "An Exhibit Attached As Part Of The Deed" in March 1938. The defining feature of Taylor's plan for Forest Hill Park was the Great Meadow, which stretched from the site of the Rockefeller residence to Lee Boulevard. Along with other Olmstedian features, it is the link to Central Park. The smaller Meadow Vista lies to the north of Forest Hills Boulevard. Taylor placed the recreation fields and parking lots on the perimeter of the 235-acre park and incorporated, on a large part, the estate's carriage roads into the park's wooded walks and trails. (Courtesy of the City of East Cleveland.)

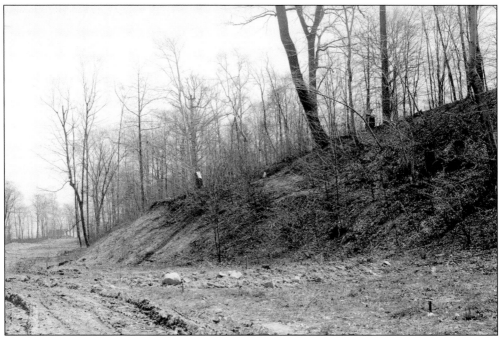

While the completion of Forest Hills Boulevard and the extension of Terrace Road through the Rockefeller estate in 1936 by the WPA predate the establishment of Forest Hill Park and the work of A. D. Taylor, they would have a considerable effect on the land. These two views are dated April 24, 1936, and face east toward the lake and Lee Boulevard. Two engineers stand on the knoll to the right. (Courtesy of the City of East Cleveland.)

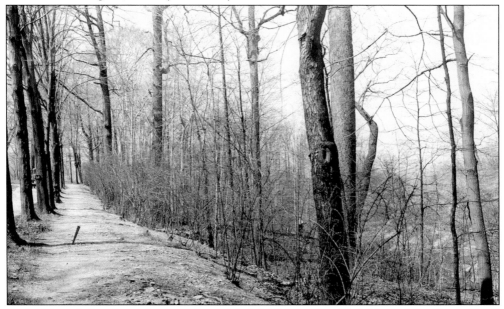

Both this and the above photograph are labeled "Forest Hills Blvd. Rockefeller Estate Knoll about Sta. 17 + 80." This view was taken from the top of the knoll on the walk next to John D. Rockefeller's horse track. An engineer's stake is visible on the walk, and a car is parked on the track at the far left. (Courtesy of the City of East Cleveland.)

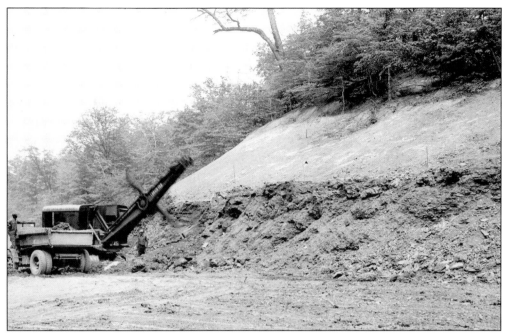

Dated May 23, 1936, these two photographs are only labeled "Forest Hills Blvd.," but were presumably taken of the progress in the excavation of the curve below Lee Boulevard and the lake. The road through the east ravine of the estate to Euclid Avenue and Eddy Road had been planned in 1929 by the Abeyton Realty Corporation to facilitate access to the Forest Hill Development. (Courtesy of the City of East Cleveland.)

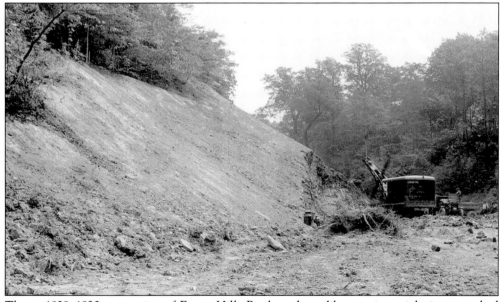

The c. 1929–1930 excavation of Forest Hills Boulevard, readily seen in aerial views, reached Fernwood Avenue just one block south of Euclid Avenue and Eddy Road. The injunction filed by five property owners in the Knight and Richardson allotment was upheld in 1931; as a result, in 1936, Forest Hills Boulevard was instead constructed entirely through the estate to Euclid Avenue and to the gatehouse. (Courtesy of the City of East Cleveland.)

The next four photographs are all dated July 11, 1936, and were taken at or near the intersection of Forest Hills Boulevard and Terrace Road. The construction of Forest Hills Boulevard divided the estate into two parts. In this eastward view, the curbing is in place and in the distance the boulevard curves out of sight toward Lee Boulevard. (Courtesy of the City of East Cleveland.)

An embankment was constructed to carry the extension of Terrace Road across the Dugway Brook Valley to Superior Avenue. Dugway Brook, which was still open in 1936, was channeled through a culvert under this embankment. This view looks across the embankment toward the apartments on Superior and Forest Hill Avenues. (Courtesy of the City of East Cleveland.)

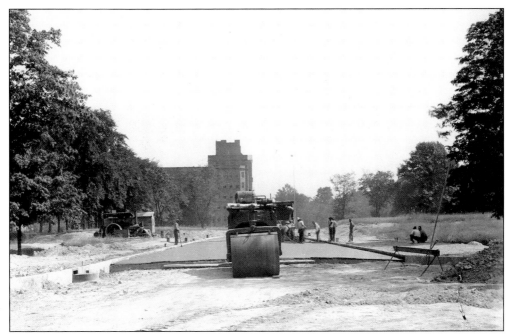

Taken from the same location, this view looks toward Huron Road Hospital and across the site of the estate's gardens and orchards. The row of trees to the left lined the road that ran down the orchard and can be seen in the photograph of the Frost family picnic. To the right, two workmen are crouched at the site of the lily pond, which escaped not only the construction of these two roads in 1936, but also the excavation in 1930. (Courtesy of the City of East Cleveland.)

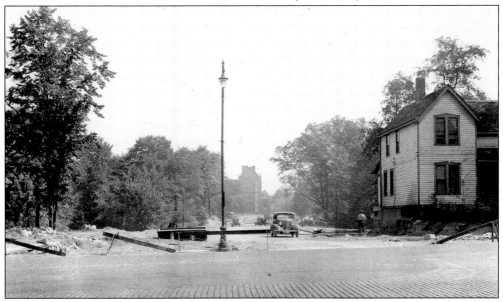

This view looks from the intersection of Superior and Forest Hill Avenues across the embankment (Terrace Road) toward Huron Road Hospital. Superior Avenue had been widened to four lanes, paved, and lighted with impressive streetlamps in 1924. The farmhouse on the right was at one of the entrances to the estate and the Dugway Brook Valley. (Courtesy of the City of East Cleveland.)

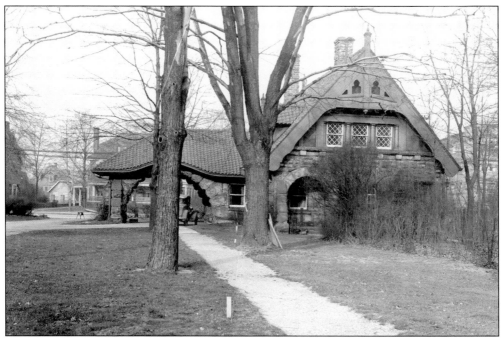

Dated January 14, 1936, this is one of the last photographs of the gatehouse on Euclid Avenue. It was razed in February 1936 as construction began on Forest Hills Boulevard. Through the archway of the porte cochere can be seen the one home on Euclid Avenue that still faces the site of the entrance to the estate. (Courtesy of the City of East Cleveland.)

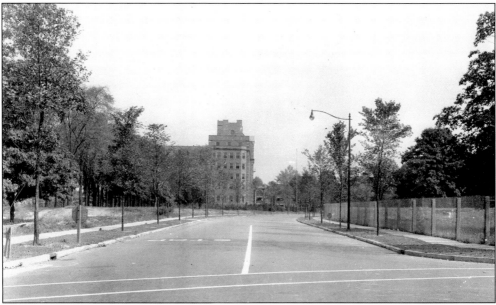

One year later, construction on Terrace Road is finished. The next three photographs are dated September 29, 1937. Looking toward Huron Road Hospital, this view shows Terrace Road curving to the right in front of the hospital. The estate on the right has been enclosed with a chain-link fence. The site is now the location of the approach to Forest Hill Park's bowling green. (Courtesy of the City of East Cleveland.)

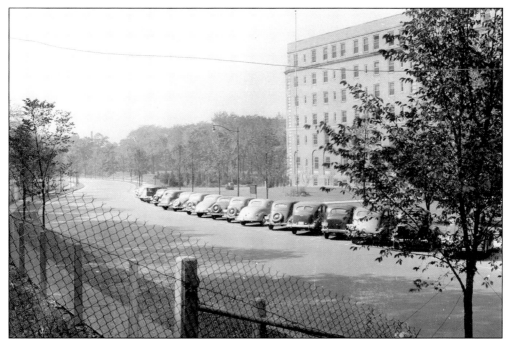

Until 1937, access to Huron Road Hospital was gained from Belmore Road. With the completion of the Terrace Road extension, a long row of diagonal parking in front of the main entrance to the hospital was attained. Parts of the orchard and gardens of the estate remained adjacent to the hospital, including the double row of trees going right up to the hospital's Belmore Road wing. (Courtesy of the City of East Cleveland.)

This is a very rare view of Forest Hills Boulevard at Euclid Avenue, looking across the streetcar tracks to the boulevard as it curves to the left toward Terrace Road. This area was the site of the estate's entrance and gatehouse. In 1875, it had been Grove Street and the carriage road to the Euclid Avenue Forest Hill Association's hotel and water cure. (Courtesy of the City of East Cleveland.)

Without a doubt the most impressive engineering feat in the development of Forest Hill Park was the construction of the high-level footbridge across Forest Hills Boulevard about halfway between Terrace Road and Lee Boulevard. Its progress was well documented by the City of East Cleveland's engineering department and metropolitan newspapers. These two photographs are dated June 12, 1939. (Courtesy of the City of East Cleveland.)

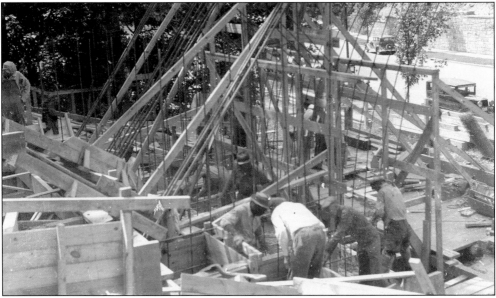

Construction of the abutments to support the bridge began in the spring of 1939. The ravine's sandstone retaining walls at this wide curve in the boulevard can be seen below. In October 1940, Jay Downer wrote to the WPA project manager of District No. 4, Frank Miskell, that John D. Rockefeller Jr. "was quick to realize that a high-level footbridge was necessary to connect and provide circulation between the two sides of the park." (Courtesy of the City of East Cleveland.)

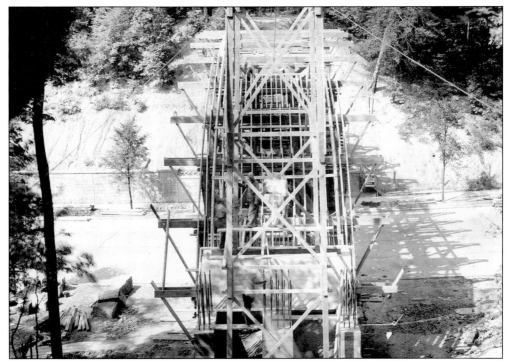

By August 14, 1939, the timbering for the structure was nearing completion. John D. Rockefeller Jr. not only donated the land for Forest Hill Park and underwrote the cost of the development plan, but also contributed $27,000, the sponsor's share that leveraged WPA funding, toward the construction of the bridge. The WPA's estimate in 1938 for the total cost of a sandstone-faced bridge was $128,000. (Courtesy of the City of East Cleveland.)

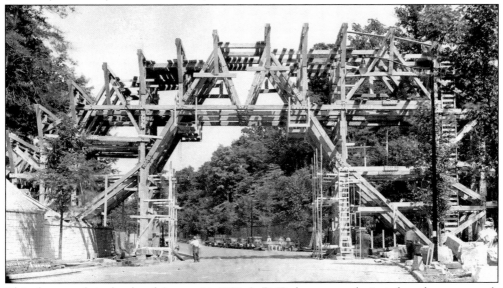

This photograph is also dated August 14, 1939. A. D. Taylor proposed a "reinforced concrete arch bridge, veneered with stone" to connect the "plateaus on either side of Forest Hill Boulevard." As an alternative design, he suggested a steel bridge. Here large blocks of sandstone rest on timbers and line the boulevard to the right. (Courtesy of the City of East Cleveland.)

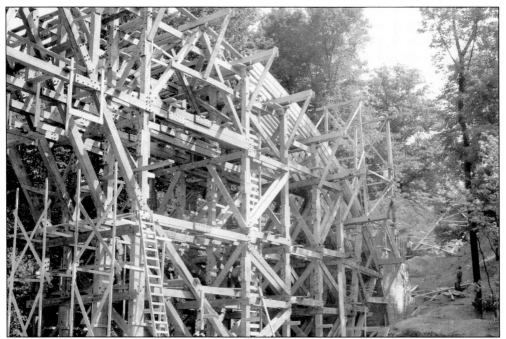

A mason, to the far right in this August 14, 1939, image, appears to be scoring blocks of yellow sandstone that came from the quarry in Berea, Ohio. By November 22, 1939, A. D. Taylor could report to Jay Downer in New York that the sandstone facing was about one-third to the top of the bridge, but because of the scaffolding he was not able to take photographs. (Courtesy of the City of East Cleveland.)

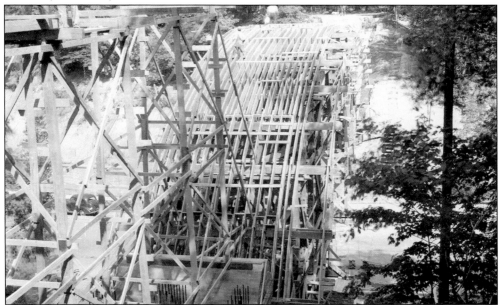

A. D. Taylor also expressed concern in the same letter to Jay Downer that the stone masonry work on the bridge was not being constructed in a uniform character or adhering to the sample wall and stone texture that Downer had selected. Indeed, three small sample stonewalls had been built in varying patterns of random ashlar. (Courtesy of the City of East Cleveland.)

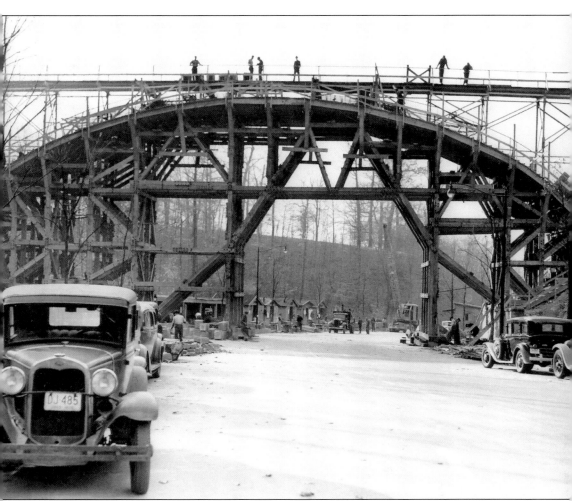

The high-level footbridge was the collaboration of three prominent Clevelanders, all with national reputations in their respective fields. The span was designed by Wilbur J. Watson, a civil engineer who planned such projects as the Lorain Carnegie (Hope Memorial) Bridge. The collaborating architect was Frank S. Walker of the firm of Walker and Weeks. His firm practiced from 1911 to 1949 and produced some of Cleveland's most outstanding buildings. The consulting landscape architect was A. D. Taylor. The bridge was completed in 1940. Its footpath spans the boulevard by 347 feet, and it arches across the roadway 140 feet. WPA workers stand on scaffolding at the footpath and railing level of the bridge in this dramatic photograph, taken by Walter Kneal and dated November 16, 1939. The construction sheds lining the boulevard, along with huge blocks of sandstone, can be seen on the left. (Courtesy of Cleveland State University Special Collections.)

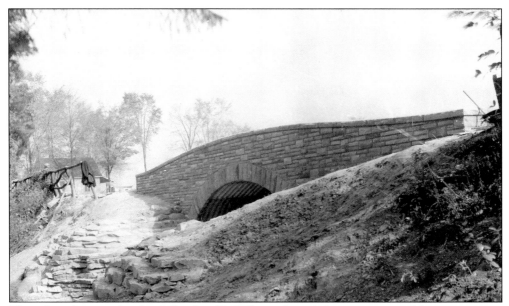

These four photographs, dated October 18, 1939, are the only known images of the construction of the dam, bridge, and spillway that replaced the Rockefeller estate's earthen dam and lake drive. A. D. Taylor did not show a design in his development plan for a footbridge across the outlet, but this small, graceful, sandstone bridge conforms to the style of architecture he advocated for the park. (Courtesy of the City of East Cleveland.)

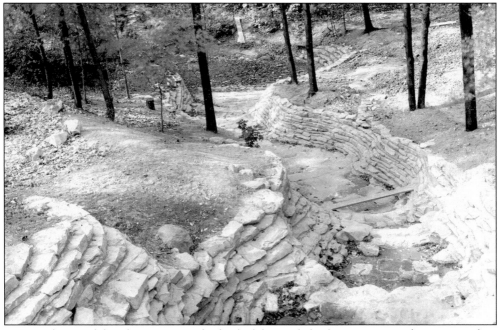

A. D. Taylor noted that the existing outlet for the lake needed to be reconstructed, recommending that "a naturalistic stone masonry spillway ought to be carefully designed in detail and equally carefully constructed." The water from the lake was the source of Rockefeller Brook, which traversed the east ravine to Euclid Avenue and, by 1939, had been diverted into a culvert under Forest Hills Boulevard. (Courtesy of the City of East Cleveland.)

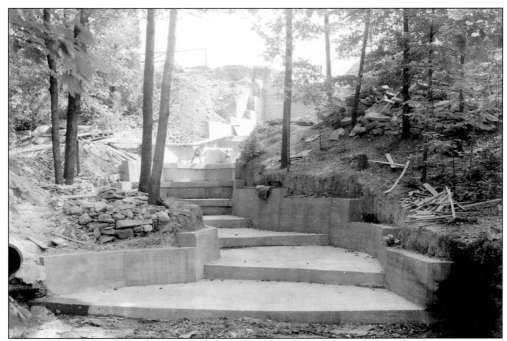

WPA workers constructed a series of concrete steps down the spillway, or cascades, to the open valley floor below. Both the site plan for the dam and spillway prepared by the City of East Cleveland's engineering department in January 1939 and A. D. Taylor's planting plan in 1940 show a lower pool in this area below the lake. In Rockefeller's time, a carriage road curved through the east ravine below the dam. (Courtesy of the City of East Cleveland.)

The WPA lined sandstone along the spillway walls and the lower pool, where the brook flowed toward the culvert. Above and next to the sandstone bridge, a worker's coat hangs on a remaining portion of the rustic railing, which was made of the branches that had for years guarded the lake drive across the dam. (Courtesy of the City of East Cleveland.)

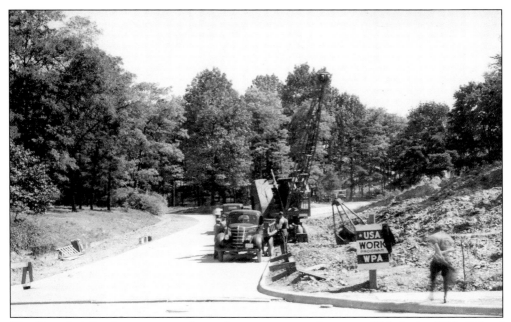

The Beersford Road entrance to the park was constructed next to Kirk Junior High School through a ravine on the estate's property. In this photograph, dated September 11, 1939, the road curves uphill to a parking lot still in use. Cars were excluded from Forest Hill Park, and like A. D. Taylor's other parking lots, this one was placed on the perimeter and concealed behind earthen embankments. (Courtesy of the City of East Cleveland.)

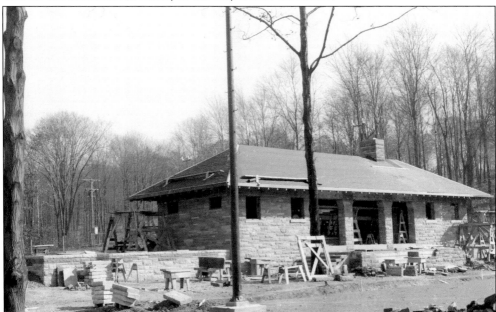

Although A. D. Taylor designed a bowling green on the plateau above Terrace Road near Forest Hills Boulevard, his 1938 plan did not specify a shelter for the sport. The construction of a pavilion or shelter for the participants was a late addition to the park's building program. These photographs are dated November 2, 1940, and show the distinct rustic architecture of one of the park's treasures. (Courtesy of the City of East Cleveland.)

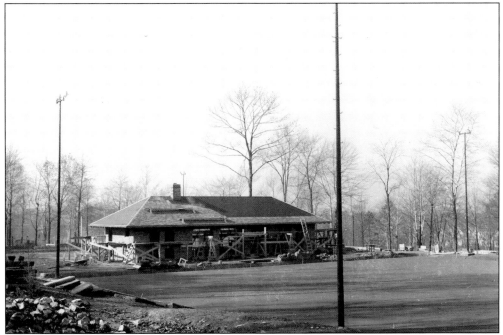

Two bowling greens were laid out and a shelter built between them. The low horizontal building, constructed with a hipped roof and an open arcaded central pavilion with a fireplace and rooms at each end, is almost a carbon copy of the boathouse that A. D. Taylor illustrated in his 1938 development plan. This view looks west toward the intersection of Terrace Road and Forest Hills Boulevard. (Courtesy of the City of East Cleveland.)

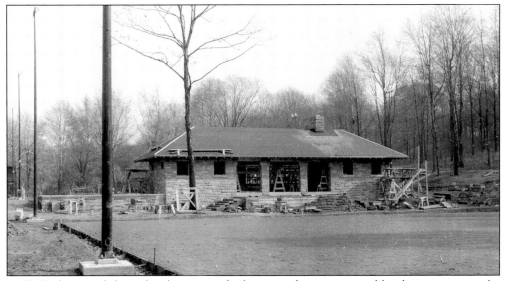

A. D. Taylor noted that a bowling green facility was often maintained by the group using the green. For many years, this bowling green has been leased and maintained by a lawn bowling club with membership open to the public. By April 27, 1941, the *New York Herald Tribune* would report that $2,039,547 had been spent on the construction of the park and that the bowling green and shelter was "the first of its kind in Ohio." (Courtesy of the City of East Cleveland.)

The trail coming down through the woodlands from the upper plateau, shown here in 1940, is a carriage road from the Rockefeller estate that was incorporated into the park's walks and circulation system. In 1938, A. D. Taylor found six and a half miles of gravel roads on the estate that he described as "well graded, unusually well constructed and excellently located." (Courtesy of the City of East Cleveland.)

The carriage road from the upper plateau descends toward the bowling green through a thick woodland of maple trees. It is today one of the most beautiful spots in the park and is virtually untouched since Rockefeller's time. The trail is still high enough that every now and then in a break in the trees the buildings of downtown Cleveland can be seen in the distance.

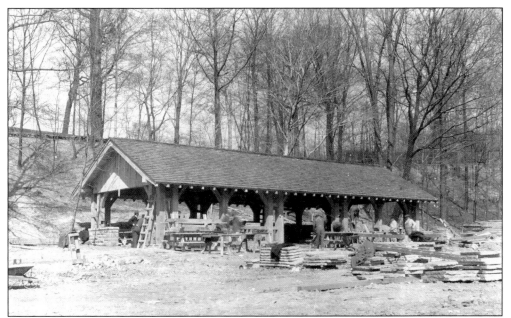

The architecture of this shelter in the picnic area in the lower Dugway Valley is a departure from the sandstone shelters built in the rest of the park. In November 1939, A. D. Taylor reported to Jay Downer that the foundations for this shelter had been completed. The addition of a parking lot was late in the building program. These two photographs are undated. (Courtesy of the City of East Cleveland.)

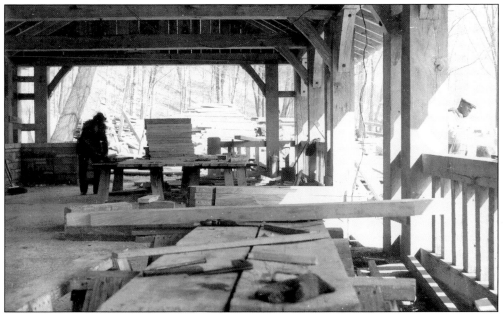

The picnic shelter is open on all four sides. Its hip roof is supported by a massive wooden beam and truss construction, and it is enclosed with a low sandstone wall at the back and a railing at the front. The shelter seems to have much in common with the ones built in the same timeframe by the WPA in the Euclid Creek and North Chagrin Reservations of the Cleveland Metroparks. (Courtesy of the City of East Cleveland.)

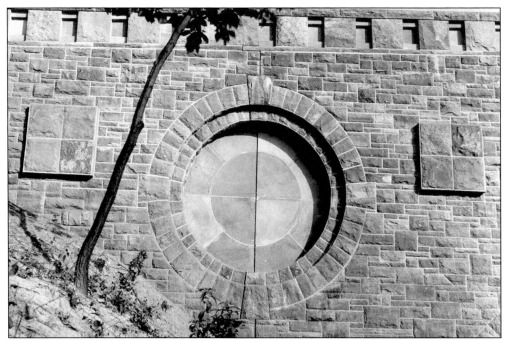

There is considerable architectural detail on the high-level footbridge, as illustrated by these two photographs, dated October 24, 1940. Four medallions—two on each side of the bridge—are recessed into the wall. The architect specified that the inside sandstone facing of the medallions be "crandalled face," or finished with a tool called a crandall that textures the surface of the stone. The sandstone squares to each side of the medallions were hammered to look like rough rock. (Courtesy of the City of East Cleveland.)

The railing of the high-level footbridge was constructed with large blocks of sandstone laid in the pattern of a parapet wall. From a distance, it does indeed look like the battlement of a castle wall. The sandstone facing was anchored to the reinforced concrete bridge with wrought iron U-ties and laid in random ashlar to conform with the pattern and texture of the sample wall. (Courtesy of the City of East Cleveland.)

This close-up photograph of the parapet wall, actually the railing for the bridge, shows the construction of the large sandstone blocks, which were also hammered to look like rough rock. The recessed blocks of sandstone were crandalled, creating a texture that today is still well preserved. The railing was capped with large pieces of sandstone and hammered on the side facing the boulevard.

The approach to the high-level footbridge, seen in the distance to the left, is from the upper plateau and north side of the park and through the Meadow Vista. This smaller meadow was created in an oak and maple woodland and was to have a small rustic overlook shelter with a view toward the west and Lake Erie.

The railings terminate well into the park and are capped with a round piece of sandstone tooled in a pattern to resemble a wheel and spokes. Perhaps the masons were thinking of the bicyclists who would use the park or those who had already used the roads on the estate. John D. Rockefeller often led his family and friends on bicycle rides through Forest Hill on moonlit nights in a game of follow the leader.

The skilled masons who worked on the construction of Forest Hill Park were part of a workforce that numbered 750 at the height of the WPA. The City of East Cleveland worked closely with the organization. Its engineering department, which had been augmented to about 30 prior to World War II, was down to 2 by 1942. Even the city's chief engineer, Max W. Garnett, was by then a captain in the Army Engineering Corps.

From the Meadow Vista, the high-level footbridge leads to the Great Meadow. Below the railing at the curb is a long-forgotten feature. The architect designed and specified planting pockets on the blueprint. The recessed area of the curb was to hold vines, and as shown on the architect's detailed rendering, they would trail over the railing of the bridge.

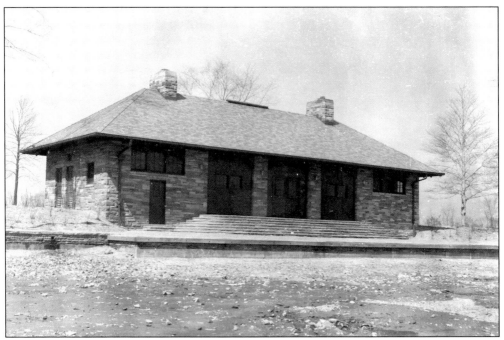

A. D. Taylor recommended that the lake be enlarged and graded to a depth of three and a half feet. The boathouse was designed to serve several purposes. The left side, with a floor at lake level, was for the storage of boats. The structure also became a shelter for ice-skating in the winter and, like the shelter at the bowling green, had a wood-burning fireplace. The doors were for winter use only. (Courtesy of the City of East Cleveland.)

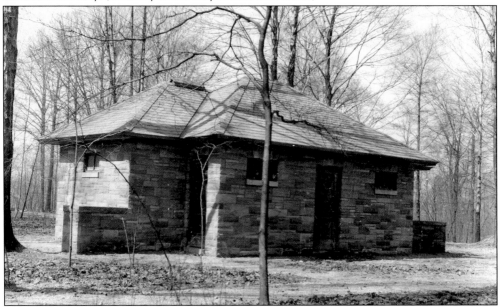

Two comfort stations were built—one in the lower Dugway Brook Valley and this one in the Meadow Vista. Even these small structures were constructed in the same rustic style as the shelters, with low horizontal lines, hip roofs, and sandstone walls meant to blend in with the natural surroundings of the park. (Courtesy of the City of East Cleveland.)

The contour of the lake across from the boathouse has remained relatively unchanged since the Rockefeller family used the lake. This is the site of the family's Victorian boathouse and windmill, not far from the corner of Lee and Forest Hills Boulevards. The view looks toward the dam, footbridge, and spillway, seen to the right, which was constructed by the WPA in 1939.

The small footbridge crossing the lake's outlet and spillway has a railing that was also hand-tooled by the masons who worked for the WPA. The outlet from the lake was enlarged and moved slightly to the south when the spillway was constructed. The water from the lake falls or cascades down the steps about 30 feet to the valley floor.

This is one of the best-preserved retaining walls found today in Forest Hill Park from the Rockefeller era. It was located just below one of the golf greens on a carriage road that ran from the barns and stables along the edge of the Dugway Valley ravine to Lee Road.

This road runs high above and at the top of the steep walls of the ravine in the upper reaches of the Dugway Brook. In Rockefeller's time, a rustic railing like the one across the lake drive was to the left. In this vicinity, the carriage road crossed a grape arbor bridge, another well-known feature of the estate. Today this area in Cleveland Heights has been incorporated into the nature trail that leads to the Rockefeller quarry.

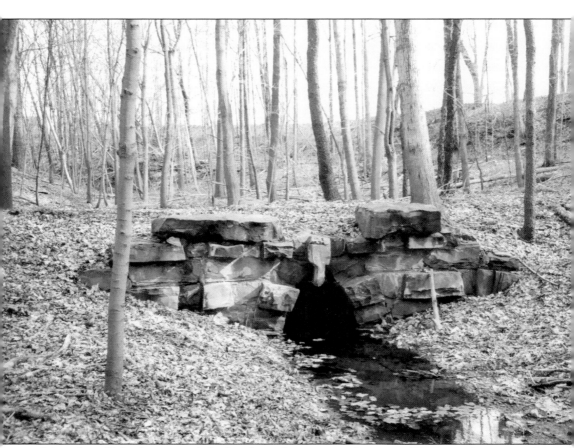

More than 20 bridges crossed the brooks and ravines on the estate. They varied in size and construction, and their location is well documented in the 1898 atlas. With the exception of the main carriage road bridge below the residence, they were all fairly small rustic bridges. Many were faced with boulders and arched over the brooks. Others were constructed of large blocks of hewn sandstone, and most likely they were all constructed from materials found on the property and from the Rockefeller quarry. By the time A. D. Taylor conducted his study and development plan in 1938, the construction of Forest Hills Boulevard had destroyed the bridges in the east ravine. Taylor found those remaining on the property to be "distinctive and well constructed." The decision to culvert the lower valley of Dugway Brook in 1939 further reduced the number of extant bridges. Today only three remain. This charming little bridge with its keystone can be found in the quarry area.

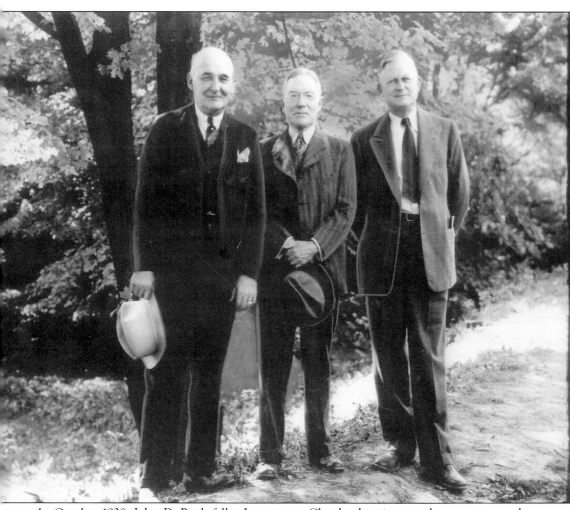

In October 1938, John D. Rockefeller Jr. came to Cleveland to inspect the progress on the construction and development of Forest Hill Park. This photograph, taken by A. D. Taylor, appeared in several Cleveland newspapers on December 1, 1938. Pictured here are James C. Jones (left), Rockefeller's Cleveland agent and sales manager of the Forest Hill Development; John D. Rockefeller Jr. (center); and Jay Downer, former chief engineer of the Bronx River Parkway and Westchester County and Rockefeller's park expert and liaison on the development of Forest Hill Park. The group explored the park, visited the Rockefeller grave site at Lake View Cemetery, and drove through the Forest Hill allotment. Late in the morning they picked up A. D. Taylor and continued to tour the park. They had lunch at Damon's in Cleveland Heights and in the afternoon drove through Wade, Rockefeller, and Gordon Parks. Rockefeller expressed not only his approval on the development of the park but praise for the work of A. D. Taylor. (Courtesy of Cleveland State University Special Collections.)

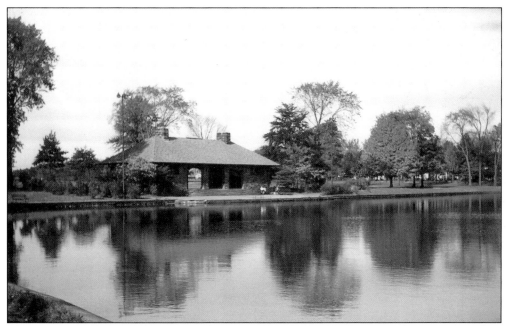

This 1958 view looks northeast toward Lee Boulevard. The boathouse, with its open pavilion and arcaded entrance on both its north and south sides, continues to provide a passage on the way to the waterfall cascades, the woodland trails, the high-level bridge, and the Great Meadow. (Courtesy of the Forest Hill Historic Preservation Society.)

The estate's massive wooden barns and stables dating from the 1880s survived well into the 20th century. Once on the edge of John D. Rockefeller's golf course and a short distance from the horse track, they were a familiar sight to park visitors as part of the Great Meadow. They were destroyed by fire in 1964. (Courtesy of the Forest Hill Historic Preservation Society.)

With the beginning of World War II, final work on the construction of Forest Hill Park came to a halt. Charles Carren, East Cleveland city manager, wrote to Jay Downer that a few projects were postponed for the duration of the war. Yet, much of A. D. Taylor's plan had been completed. As seen in these photographs by Cleveland Heights resident Lois Cook in 1958, Forest Hill Park had entered its golden years. Today Forest Hill Park retains substantial sections of its historic landscape. Those areas were placed on the National Register of Historic Places in 1998 under the sponsorship of the Forest Hill Historic Preservation Society. (Courtesy of the Forest Hill Historic Preservation Society.)

BIBLIOGRAPHY

Arthur, Allan. *The Country Club: Its First 75 Years, 1889–1964*. Cleveland: Lezius-Miles Company, 1964.

Avery, Elroy McKendree. *A History of Cleveland and Its Environs*, 3 vols., Chicago: the Lewis Publishing Company, 1918.

Campbell, Thomas F. and Edward M. Miggins, editors. *The Birth of Modern Cleveland 1865 1930*. Cleveland: Western Reserve Historical Society, 1988.

Chernow, Ron. *Titan: The Life of John D. Rockefeller, Sr.* New York: Random House, 1998.

Cigliano, Jan. *Showplace of America: Cleveland's Euclid Avenue, 1850–1910*. Kent, Ohio: the Kent State University Press, 1993.

Ernst, Joseph W. *"Dear Father"/"Dear Son": Correspondence of John D. Rockefeller and John D. Rockefeller, Jr.* New York: Fordham University Press, 1994.

Goulder, Grace. *John D. Rockefeller: The Cleveland Years*. Cleveland: Western Reserve Historical Society, 1972.

Johanessen, Eric. *Cleveland Architecture 1876–1976*. Cleveland: Western Reserve Historical Society, 1979.

—*From Town to Tower*. Cleveland: Western Reserve Historical Society, 1983.

Keating, W. Dennis, Norman Krumholz and David C. Perry, editors. *Cleveland: A Metropolitan Reader*. Kent, Ohio: the Kent State University Press, 1995.

Mayfield Country Club. *Mayfield Country Club 1911–1986*. Cleveland, 1986.

McCarthy, John R. *The Parish of Saint Philomena: A Record of Ninety Years of Witness in the Community of East Cleveland, Ohio 1902–1992*. Cleveland: Coventry Litho, 1992.

Nevins, Allan. *Study in Power: John D. Rockefeller, Industrialist and Philanthropist*, 2 vols., New York: Charles Scribner's Sons, 1953.

Read, Florence Matilda. *The Story of Spelman College*. Princeton: Princeton University Press, 1961.

Taylor, A. D. *Forest Hill Park: A Report on the Proposed Landscape Development*. Cleveland: the Caxton Company, 1938

Tishler, William, H., editor. *American Landscape Architecture: Designers And Places*. Washington, D.C.: the Preservation Press, 1989.

DISCOVER THOUSANDS OF LOCAL HISTORY BOOKS
FEATURING MILLIONS OF VINTAGE IMAGES

Arcadia Publishing, the leading local history publisher in the United States, is committed to making history accessible and meaningful through publishing books that celebrate and preserve the heritage of America's people and places.

Find more books like this at
www.arcadiapublishing.com

Search for your hometown history, your old stomping grounds, and even your favorite sports team.